THE GREAT WESTERN RAILWAY

—— VOLUME ONE ——
PADDINGTON TO BRISTOL

Stanley C. Jenkins & Martin Loader

AMBERLEY

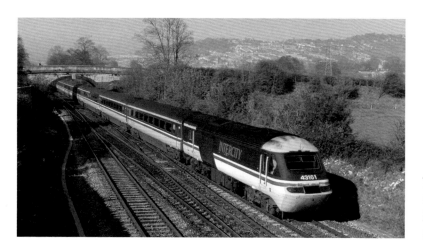

ACKNOWLEDGEMENTS

Thanks are due to Dr Peter Fidczuk (pages 11, 13, 65, 66, 67, 68 and 69) and Mike Marr (pages 15–16) for the supply of photographs used in this book. Other images were obtained from the Lens of Sutton Collection, and from the authors' own collections.

A High Speed Train at Bathampton
The 9.20 a.m. service from Bristol Temple Meads to Paddington speeds past Bathampton Junction, on the Great Western main line near Bath, on 5 April 1990.

First published 2014

Amberley Publishing
The Hill, Stroud, Gloucestershire, GL5 4EP
www.amberley-books.com

Copyright © Stanley C. Jenkins & Martin Loader, 2014

The right of Stanley C. Jenkins & Martin Loader to be identified as the Authors of this work has been asserted in accordance with the Copyrights, Designs and Patents Act 1988.

ISBN 978 1 4456 1824 1 (print)
ISBN 978 1 4456 1832 6 (ebook)

British Library Cataloguing in Publication Data.
A catalogue record for this book is available from the British Library.

Typesetting by Amberley Publishing.
Printed in Great Britain.

INTRODUCTION

The Great Western Railway Company was incorporated by Act of Parliament on 31 August 1835, with powers for the construction of a railway between Bristol, Bath, Reading and London. The new railway was to commence 'at or near a certain Field called Temple Mead within the Parish of Temple otherwise Holy Cross in the City and County of the City of Bristol' and terminate by 'a Junction with the London & Birmingham Railway in a certain Field lying between the Paddington Canal and the Turnpike Road leading from London to Harrow on the western side of the General Cemetery in the Parish or Township of Hammersmith in the ... County of Middlesex'. To pay for their scheme, the promoters were empowered to raise £2.5 million in shares and a further £833,333 by loans – a total of £3,333,333, which was, needless to say, an incredible sum by 1830s standards.

As originally proposed, the Great Western Railway (GWR) would have been built as a 4-foot 8½-inch gauge line. This assumption was implicit in the 1835 Act, which envisaged that GWR trains would run to and from the London & Birmingham Railway terminus at Euston. However, Isambard Kingdom Brunel (1801–59), the Great Western engineer, recommended that the line should be built to a broad gauge of 7 feet 0¼ inch, and this suggestion was accepted by the GWR directors. In June 1836, a contract was awarded for construction of the line between Hanwell and Acton, and work was soon in progress. In the meantime, it was agreed that the GWR would build an independent terminus at Paddington – the idea of using Euston station having been abandoned. Parliamentary consent for the proposed deviation between Acton and Paddington was obtained on 3 July 1837, by which time the major earthworks between London and Maidenhead were substantially complete.

The first section of the GWR main line was ceremonially opened on 31 May 1838, when a special train conveyed the directors and their invited guests from Paddington to a temporary terminus at Maidenhead. The inaugural train was hauled by the 2-2-2 locomotive *North Star*, and it accomplished the 22-mile 43-chain journey from London in 49 minutes. After inspecting the railway installations at Maidenhead the official party returned to Salt Hill, near Slough, where about 300 people sat down to a cold luncheon in a marquee. Regular public services commenced on Monday 4 June 1838, with an initial service of four trains each way.

The line was extended westwards to Twyford on 1 July 1839, to Reading on 30 March 1840, and to Steventon on 1 June 1840. Further sections of the line were opened at intervals, and the GWR route was completed throughout its 118-mile length from London to Bristol Temple Meads on 30 June 1841.

The GWR main line was originally a double-track, broad-gauge route, but as traffic developed during the nineteenth century the GWR added additional up and down 'slow' lines to the north of the main lines. This 'widening' operation had been completed as far west as Southall by 1878, while the line was eventually quadrupled as far west as Didcot – with additional four-track sections between Didcot and Swindon. The two sets of up and down lines became known as the 'main line' and 'relief line' during the 1880s, and these terms have remained in use until the present day.

SUBSEQUENT DEVELOPMENTS

Branch lines were opened throughout the Victorian period and, as a result, several of the intermediate stopping places between Paddington and Bristol became junction stations. West Ealing, for example, became the junction for local services to Greenford, and Southall became the starting point for the Brentford Dock branch; Maidenhead was, similarly, the junction for the Wycombe Railway, while West Drayton, Twyford and Cholsey & Moulsford were the junctions for the Staines, Henley-on-Thames and Wallingford branch lines respectively.

In the meantime, the GWR broad gauge system had continued to expand, as the West of England main line was pushed westwards in stages. The Bristol & Exeter Railway was opened in 1844, and the South Devon Railway reached Plymouth in 1848, while the final links were provided by the West Cornwall Railway and the Cornwall Railway, which were completed in 1852 and 1859 respectively – thereby establishing a continuous line between Paddington and Penzance (albeit with a break-of-gauge at Truro).

Other important developments included the opening of the Didcot to Oxford branch in 1844, and the completion of the Cheltenham & Great Western Union line in 1845 – the Oxford route being the starting point for important main lines to Worcester, Wolverhampton, Hereford and Birmingham. The burgeoning Great Western system served Wales and the West Midlands, as well as the West Country. In this context, the South Wales line was completed throughout to Milford Haven in 1856, while the 'Northern Main Line' extended as far north as the Mersey – the northernmost extremity of the GWR system being the branch line terminus at West Kirby, at the very top of the Wirral Peninsula.

The 7-foot gauge was abandoned at the end of the nineteenth century and, at about the same time, the GWR decided to shorten its major routes between London, South Wales, the Midlands and the West of England by creating a series of 'cut-off' lines. As far as the Great Western main line was concerned, it was envisaged that two such 'cut-offs' would be built. One of these would be the upgraded 'Berks & Hants' route from Reading to Taunton, while the other would be the 'Badminton Cut-Off' between Wootton Bassett and Patchway, where the 'cut-off' would converge with the slightly earlier Severn Tunnel line to South Wales. The Badminton Cut-Off was completed in 1903, and the Berks & Hants improvement scheme was completed in 1906, giving the GWR shortened routes to South Wales and the West of England.

PADDINGTON STATION

Paddington is one of London's greatest stations, and any attempt to set out its full history would fill several volumes. When the first Great Western trains ran in 1838, they used a temporary terminus that had been set up immediately to the west of Bishop's Road – the arches of the original Bishop's Road Bridge being pressed into use as temporary offices and waiting rooms.

The present station on the east side of the Bishop's Road Bridge originated during the early 1850s, the GWR directors having authorised the construction of a 'passenger departure shed, with offices, platforms, etc' at an estimated cost of £50,000 in February 1851. They also agreed that a 'hotel with refreshment rooms, dormitories, stables and other conveniences' would be built on the Paddington site.

There was, at first, no mention of an 'arrival shed', although it was subsequently agreed that one would be built on the north side of the new terminus at a cost of £75,000. The departure platforms were ready for use by 16 January 1854, but the arrival platforms were not completed until the following May. The station was officially opened on Monday 29 May 1854, while the adjoining Great Western Royal Hotel was opened on 9 June. Prince Albert and the Prince of Wales

inspected the hotel on its opening day, and they were reported to have been 'much pleased with the house and general arrangements'.

As originally built, the 1854 station incorporated ten terminal roads beneath a triple-span overall roof. The station was aligned from east to west, and the platforms were arranged in two groups – three platform faces on the south side being used for departures, while two further platforms on the north side functioned as arrival platforms. The five platforms lines were originally separated by five carriage storage roads, which could be entered from the station throat in conventional fashion, or by means of a system of turntables at the very end of the line. These sidings were subsequently removed to make room for additional platforms, and by 1897 Paddington had nine platform lines, rising to sixteen by the 1930s.

Although primarily a passenger station, Paddington could also handle goods and parcels traffic. Paddington Goods station was sited to the north-west of the passenger terminus, extensive goods sidings and other facilities being laid-out on an attenuated site between the main running lines and the Paddington branch of the Grand Junction Canal. There was, in addition, a spacious parcels depot on the down side, and in recent years this part of the station has sometimes been pressed into use as an additional platform for main line passenger services. Passengers have to walk along the entire length of Platform 1 in order to reach trains standing alongside what has been dubbed 'Platform 1A'.

The Hammersmith & City Underground lines on the north side of the station were electrified on the 600-volt direct-current system in 1906, using third and fourth rails in accordance with Metropolitan and District Railway practice. This was the only form of electrification employed at Paddington until the late 1990s, when platforms 3, 4, 5, 6 and 11 were energised on the 25,000-volt AC system in readiness for the introduction of Heathrow Express services to Heathrow Airport. The Heathrow Express service was opened to public traffic between Paddington and Heathrow Junction on 19 January 1998, and officially opened throughout by Prime Minister Tony Blair on 23 June 1998.

Resignalling work carried in 1992 enabled the station approach lines to be used for bidirectional working, so that trains could run into or out of any of the main platforms. The revised track plan would have horrified Victorian engineers, although it was suggested that, with modern signalling, the new layout was safer than it had been in steam days, when up and down traffic was strictly segregated.

At first, the new computerised signalling system appeared to be functioning successfully, but on the morning of 5 April 1999 a working westbound local collided head-on with the 6.03 a.m. Great Western HST service from Cheltenham. The driver of class '165' unit No. 165115 had passed two yellow warning signals and a red danger signal, and proceeded onto the up main line via one of the newly installed facing points. The ensuing high-speed crash occurred 2 miles out of Paddington at Ladbrooke Grove, and resulted in the total destruction of the leading multiple-unit vehicle. The leading HST power car was derailed, together with the first-class vehicles immediately behind it, but the strongly constructed HST coaches sustained little damage. Unfortunately, the diesel fuel carried in both trains was ignited by the impact, and for this reason the number of casualties was higher than would otherwise have been the case. The final death toll was twenty-six, including the drivers of both trains.

At the time of writing, the Great Western system is being electrified between London, Oxford, Newbury, Bristol and Cardiff, and this will result in many changes in relation to bridges, stations and other infrastructure. Paddington and Reading stations are being substantially rebuilt, while further changes are taking place at the London end of the line in connection with the Crossrail project, which will result in the provision of an entirely a new rail link between Heathrow and East London.

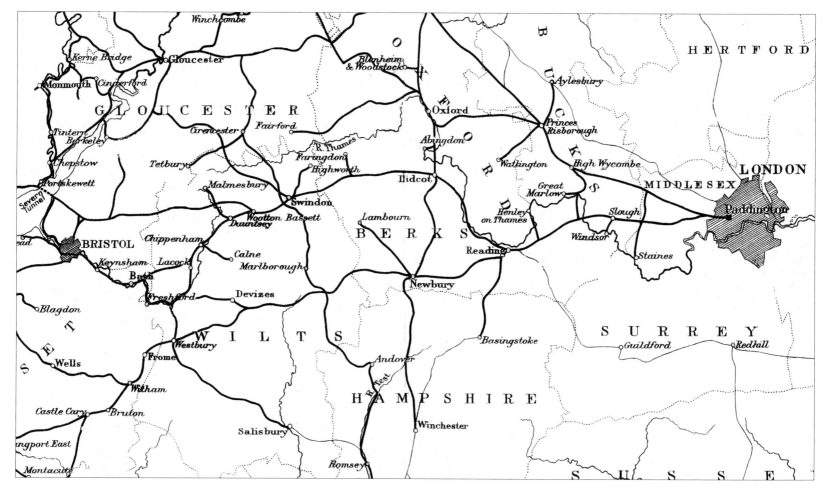

Map of the Paddington to Bristol Line

A map of the Great Western system in Wessex, showing the original main line to Bristol via Reading, Didcot, Swindon and Bath. The more direct Berks & Hants route to the West of England diverges westwards at Reading, while the 'Badminton Cut-Off' leaves the main line at Wootton Bassett, on its way to South Wales. The Berks & Hants Line is the subject of a separate Amberley publication (*The Berks & Hants Line Through Time*), and this present publication will concentrate on the old main line from Paddington to Bristol Temple Meads.

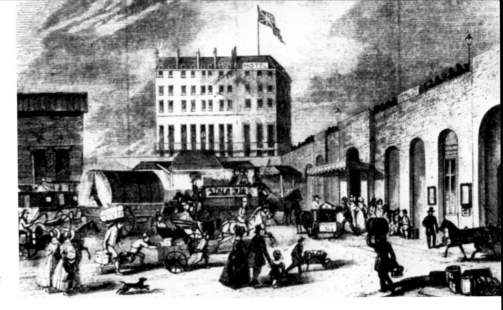

Paddington: Origins of the Station

These two views from *The Illustrated London News* depict the
temporary station that was brought into use in 1838. The Bishops
Road Bridge, seen to the right of the upper picture, was a multiple-
arched brick structure, and some of its arches were pressed into
use as a booking hall, waiting rooms and offices. The lower view
depicts the Arrival shed, which was situated on the northern side of
the station site.

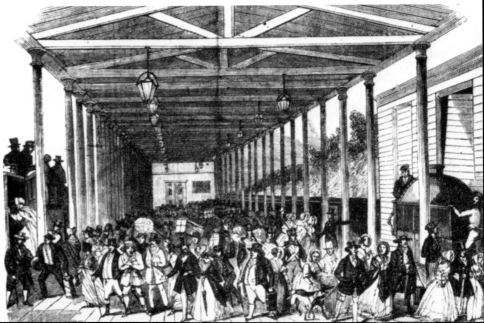

Paddington: Edwardian Locomotives

George Jackson Churchward (1857–1933), the GWR Locomotive Superintendent from 1902 until his retirement in 1921, designed only one 4-6-2 locomotive, which was built in 1908 and named *The Great Bear*. This 143-ton locomotive was the first 4-6-2 to be built in Britain but it was not a success, and the engine was withdrawn in 1914 – a few parts being utilised in the construction of a new 'Castle' class 4-6-0 named *Viscount Churchill*.

Left: The Great Bear awaiting to depart from Paddington's Platform 1.

Below left: An 'Achilles' class 4-2-2, also standing in Platform 1. *Below right:* 'Saint' class 4-6-0 No. 175 (later 2975) *Viscount Churchill*, which became *Sir Ernest Palmer* in 1924when *The Great Bear* in its 'rebuilt' form was renamed *Viscount Churchill*.

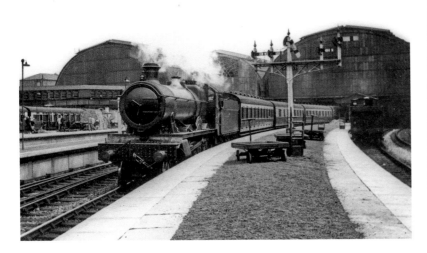

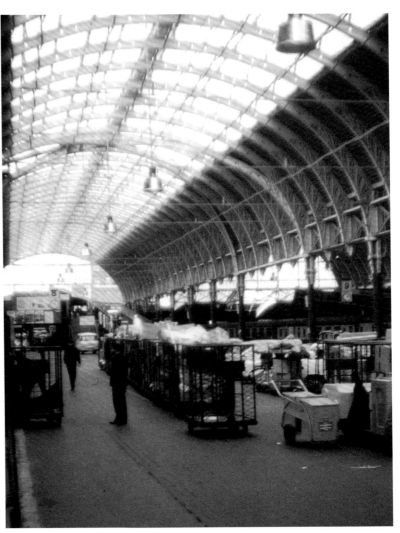

Paddington: The Fourth Roof Span

The station was rebuilt and extended on several occasions, notably in the 1890s, when the approach lines were extensively remodelled, and in the early 1900s, when three additional platforms were provided on the north side. In connection with this enlargement, a fourth bay was added to the original glass-and-iron train shed, this new structure being cleverly-designed to match the three original bays. The work was completed during the First World War, and in its February 1916 edition, *The Railway Magazine* reported that 'the large roof span over platforms Nos 9, 10 and 11' was 'nearly completed', while a new parcels depot on the up side had been brought into use. The upper view shows the western end of the station, with the fourth roof span visible to the left of the locomotive, while the colour photograph shows the interior of the train shed in 1971.

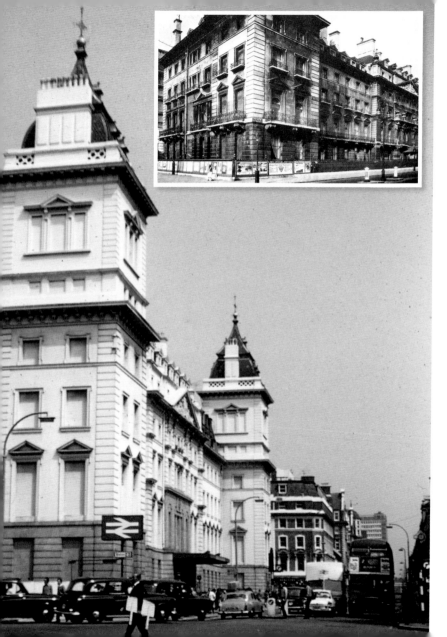

Left: Paddington: The Great Western Royal Hotel

Travellers entering the station are confronted by the massive bulk of the Great Western Royal Hotel, which is built at right angles to the buffer stops, and forms an appropriate public 'face' to the huge terminus. The hotel was designed by P. C. Hardwick in conjunction with I. K. Brunel, and its architectural features reflect the then fashionable French Renaissance style. The building incorporates 'fireproof' floors constructed on a system devised by James Barratt, and described in the *Proceedings of the Institute of Civil Engineers* Vol. XII (1853). These consisted of H-pattern girders with oak planks resting on their bottom flanges, the intervening space being filled with solid concrete. The building lost many of its ornamental balustrades and other decorative features during the 1930s – the idea being that the removal of these Victorian adornments would give the building a superficially 'modern' Art Deco appearance. The inset view shows the hotel in the early 1930s, while the photograph to the left provides a glimpse of the building in 1972.

Opposite: Paddington: The Expansion of Facilities

A considerable amount of improvement work was carried out at Paddington with the aid of cheap government loans during the 1930s. The work included platform lengthening and the installation of colour light signals on the approaches to the station. In its fully developed form, Paddington has sixteen platforms, and these are numbered in logical sequence from Platform 1 on the south side, to Platform 16 on the north. Platforms 1 to 8, the original platforms, are sited beneath the original 1854 triple-span roof, while Platforms 9 to 12, immediately to the north, are located beneath the 1916 roof span. This view shows Platform 1, the main departure platform, probably around 1950.

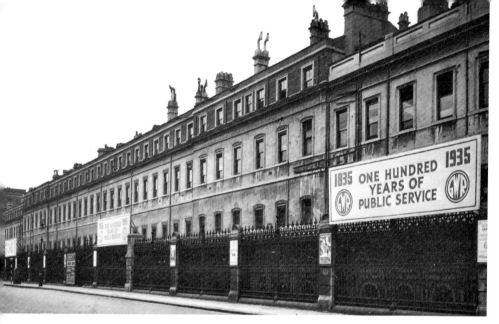

Paddington: The Main Entrances

The main station buildings and other offices are sited in Eastbourne Road, on the former 'departure side' of the terminus. The lengthy Eastbourne Road façade, which is shown in the upper view, resembles a typical Victorian domestic terrace, with vaguely Italianate features. The position of the Great Western Royal Hotel at the very end of the line means that passengers have to enter or leave the station by means of side entrances – one of these being on the departure side, while the other, slightly grander entrance is on the arrival side, as shown in the lower illustration.

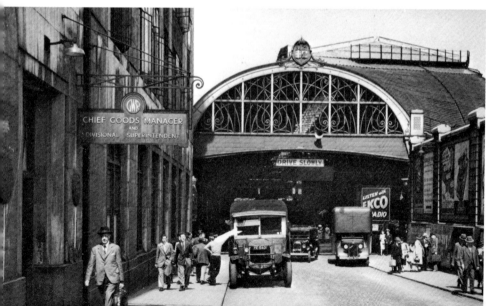

Paddington: 'The Lawn'

The area between the terminal buffer stops and the Great Western Royal Hotel has always been known as 'The Lawn', although the origins of this curiously inappropriate name remain a profound mystery. In the early days, The Lawn was occupied by a system of turntables and transverse sidings, by means of which railway vehicles could be manually transferred between the main terminal lines. Later, The Lawn was used for parcels traffic but, following the opening of a new parcels depot in the 1930s, it was developed as a spacious circulating area. The upper view shows an orchestral performance taking place on The Lawn in June 1949, while the recent colour photograph shows the illuminated departure indicator in front of platforms 4 and 5.

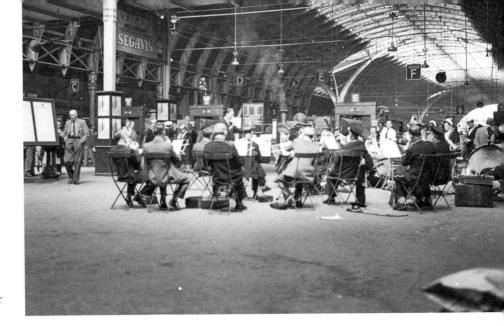

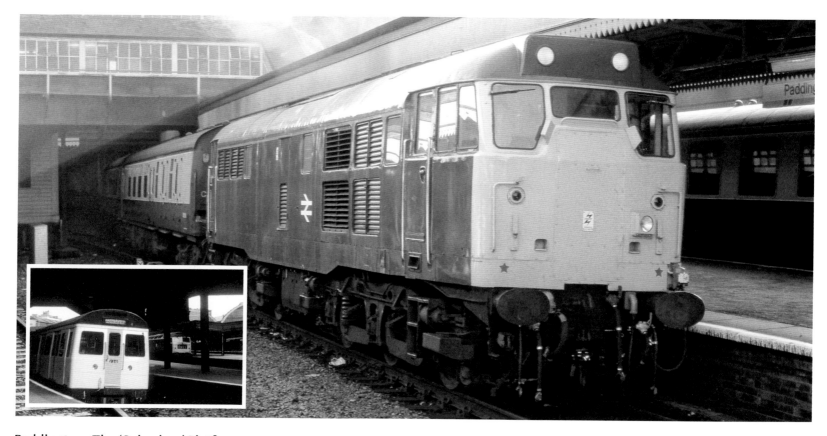

Paddington: The 'Suburban' Platforms

Platforms 13, 14, 15 and 16, on the north-west side, constitute the so-called 'Paddington Suburban' station, two of these being used by main line suburban services, while the two northernmost platforms are used by services on the Hammersmith & City branch, which was opened as long ago as 13 June 1864. This line was originally worked by the GWR, but the Metropolitan Railway took over in the following year, and the line was vested jointly in the two companies in July 1867. The photograph above shows class '31' locomotive No. 31401 in the 'Suburban' platforms on 22 November 1986. These locomotives were used employed empty stock workings between Paddington and Old Oak Common for many years. The inset view provides a glimpse of an Underground train on the Hammersmith & City Line in 1973.

Paddington: Platform Scenes

Above: Resplendent in Network South East livery, class '50' locomotive No. 50044 *Exeter* rests beneath Brunel's magnificent wrought-iron roof, having just arrived with the 8.36 a.m. train from Cheltenham on 22 November 1986. It would shortly be working the 12.17 p.m. Paddington to Oxford service, followed by the 2.00 p.m. Oxford to Paddington return working, and the 8.30 p.m. Paddington to Exeter St Davids service. Note the 'BG' parcels vehicle next to the locomotive, which is being unloaded with its interior lights on. *Below*: A detailed view of class '47' locomotive No. 47484 *Isambard Kingdom Brunel* in the platforms at Paddington around 1979.

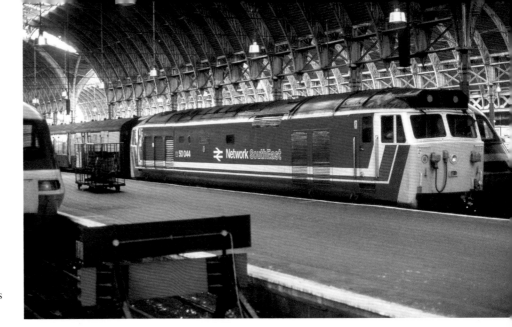

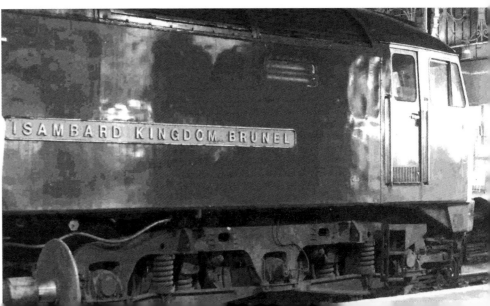

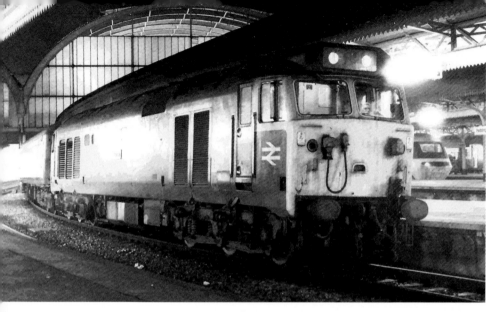

Paddington: Night Scenes

These two nocturnal photographs were taken at Paddington in around 1980. The upper view shows an unidentified class '50' locomotive, while the lower picture shows another member of the same class in Platform 3; an HST set can be seen in the adjacent Platform 2.

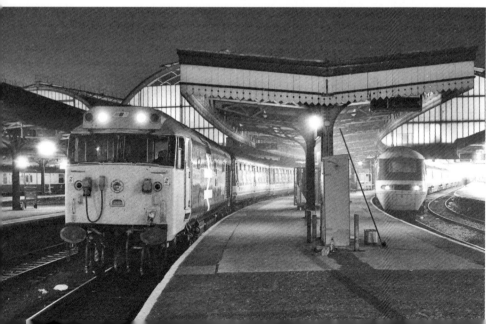

Right: Paddington: The New 'Arrival' Box

A detailed study of Paddington Arrival Signal Box, which was opened in 1933 as part of the 1930s improvement programme. Sadly, the newly built box, sited at the end of platforms 10 and 11, was badly damaged by a fire that started during the early hours of Friday 25 November 1938, and a temporary frame had to be used until the damaged box was reopened in July 1939.

Left: Paddington: The Old 'Departure' Box

An end-of-the-platform view taken at Paddington during the early 1930s. An unidentified 'Castle' class 4-6-0 stands in Platform 3, while the old 'Departure' box can be seen immediately to the east of the Bishops Road Bridge; the bridge, completed in 1907, replaced the original brick bridge seen on page 7.

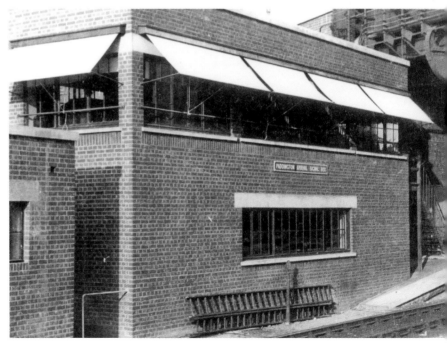

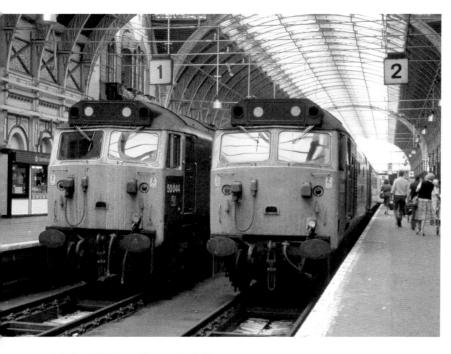

Right: Tickets from Paddington
A selection of GWR and British Railways (BR) tickets issued at Paddington station, including a platform ticket, three forces leave tickets and a Hikers Express ticket dated 23 March 1933.

Left: Paddington
Class '50' locomotive No. 50044 *Exeter* rests against the buffer stops at the end of Platform 1 on 6 August 1978, while sister locomotive No. 50010 *Monarch* waits in the adjacent Platform 2.

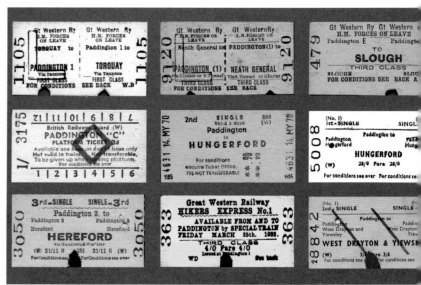

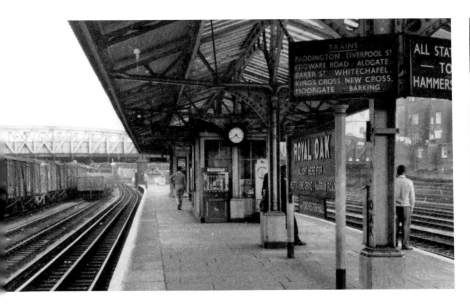 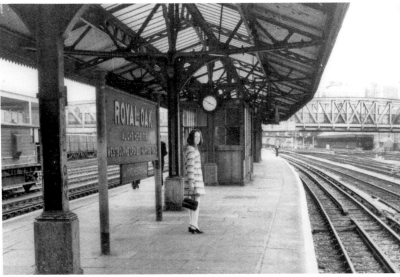

Paddington: The Hammersmith & City Line at Royal Oak

On departure from Paddington, westbound trains pass beneath a series of massive girder bridges that carry busy thoroughfares such as Bishop's Road and Westbourne Road over the multiple-tracked GWR main line. These impressive structures are named after the roads that they carry, the first half-dozen being known as Bishops Road Bridge, Westbourne Bridge, Ranelegh Bridge, Lord Hill's Bridge, Green Lane Bridge and Golbourne Road Bridge. The Underground station at Royal Oak is situated immediately to the east of the Lord's Hill Bridge, within sight of Paddington station. Opened on 30 October 1871, it was, at one time, served by main line services as well as Underground trains, but it is now used only by Hammersmith & City services. The left-hand view is looking eastwards along the island platform, while the right-hand picture looks westwards; part of Paddington goods station can be glimpsed beyond the Westbourne Road Bridge.

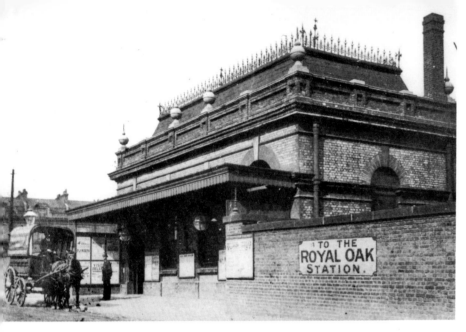

Paddington: The Hammersmith & City Line at Royal Oak

The street-level station building is sited on Lord Hill's Bridge, as shown in this Edwardian postcard view of around 1908. The lower picture, dating from the late 1960s, shows the covered stairway that links the high-level building to the platform. In common with other stations in the London suburban area, Royal Oak deals with phenomenal amounts of traffic. Great Western traffic statistics reveal that, in 1903, the station issued 822,485 tickets, while by the 1930s ticket sales amounted to around 500,000 ordinary tickets and 3,000 season tickets per annum. In practice, the apparent decline in the number of passengers can be attributed to the increased use of season tickets by regular travellers – one three-month season being the equivalent of sixty return journeys, while a six-month season equated to 120 daily journeys.

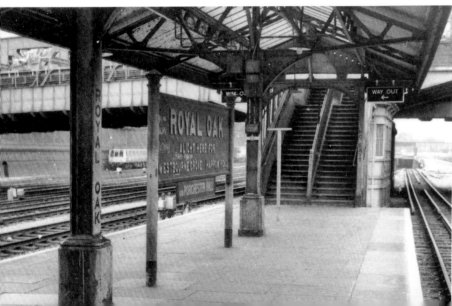

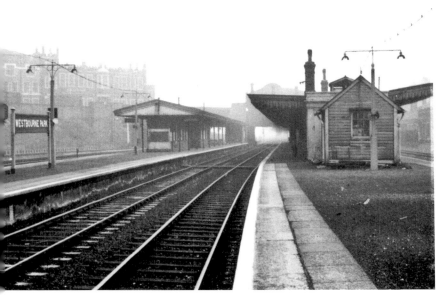
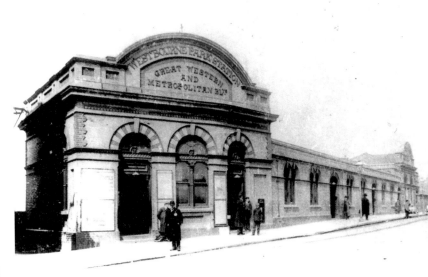

Paddington: Westbourne Park

Although many goods lines have been lifted in recent years, the approaches to the terminus are still filled with a complex web of trackwork. The main platform lines merge into six running lines, while the eastbound and westbound Hammersmith & City lines, which initially run parallel on the north side, descend to a lower level before passing beneath the main lines and reappearing on the south side. Gaining speed, main line services approach the station throat, at which point the six main running lines merge into the 'main line' and 'relief line'.

Situated just 1 mile 20 chains from Paddington station, Westbourne Park station was in existence by the mid-1860s, although the present station was opened in connection with the Hammersmith & City line on 30 October 1871. At its peak, the station had six platforms, including two for the Hammersmith line. These two postcard views show the main line platforms and the street-level booking office around 1912.

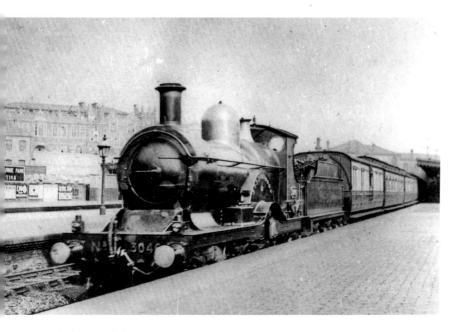

Right: Paddington: Westbourne Park

In 1902, the Great Western purchased a four-cylinder de Glehn compound 4-4-2 locomotive from French manufacturers, while two similar but slightly larger engines were delivered in 1905. The three 'Frenchmen' were acquired for experimental purposes, but they were subsequently put to work on normal services. The lower view shows one of the de Glehn compounds (probably No. 103 *President*) at the head of a Newbury Race Special in the main line platforms at Westbourne Park.

Left: Paddington: Westbourne Park

An unidentified 'Achilles' class 4-2-2 at Westbourne Park during the early years of the twentieth century; the Paddington General Hospital is visible in the distance.

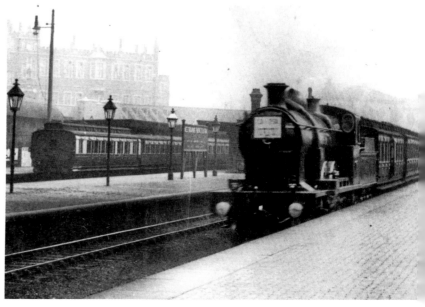

Paddington: Westbourne Park

In addition to local stopping trains, Westbourne Park was served by main line trains during the Victorian period. However, the number of long-distance services using the station was progressively reduced until, by the early twentieth century, the station had been reduced to purely suburban status. British Railway trains called until 1992 but, like neighbouring Royal Oak, Westbourne Park is now served only by Underground trains, which use the two sharply curved Hammersmith & City platforms. The accompanying photographs show the Hammersmith platforms during the 1960s.

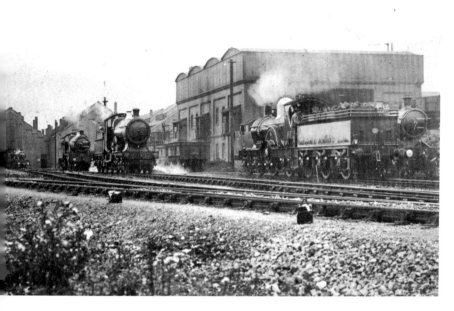
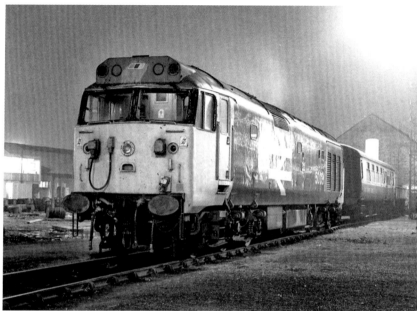

Old Oak Common

With a carriage reception line running parallel to the right, westbound workings thunder beneath Ladbrooke Grove Bridge, and are soon passing Old Oak Common depot (2 miles 65 chains). The scale of the infrastructure here is impressive, with extensive sidings on both sides of the multiple-tracked running lines and North Pole International Depot visible to the left. Old Oak Common, the largest motive power depot on the Great Western system, was opened in 1906 to replace an earlier shed at Westbourne Park, a large carriage shed and storage sidings being laid out on a contiguous site. The left-hand picture shows 4-4-0 and 4-2-2 locomotives in front of the coaling stage around 1912, while the view on the right is a night scene showing class '50' locomotive No. 50031 *Hood* at Old Oak Common during the 1980s.

North Pole Depot was a comparatively recent addition to the railway scene, having been opened in 1993 as a servicing and repair centre for Channel Tunnel trains. Extending alongside the Great Western main line for a distance of 1¾ miles, the depot contained stabling sidings, a six-road servicing shed and a four-road repair shop. Access to the rest of the railway system was via a connection from the West London line, which passes over the site at right angles. At the time of writing, North Pole Depot is being adapted for use as a depot for the IEP (Intercity Express Programme) trains, which will be employed on the Great Western main line following electrification.

Acton Main Line

Old Oak Common West Junction (3 miles 22 chains) is the starting point for the Great Western's 'New Line' to Birmingham, which was opened in stages and completed throughout in 1910, when the Bicester Cut-Off was brought into use. Heading west-south-westwards, Brunel's original line continues to Acton Main Line (4 miles 21 chains), a busy suburban station that was opened on 1 February 1868. *Right:* Looking eastwards along the up main platform in the early 1960s; the street-level station building can be seen on the Horn Lane road bridge, at the Paddington end of the platforms. *Below right:* A detailed study of the main station building, which was of standard Great Western design, with ornate French château-style end turrets. This building has now been replaced by a smaller building, which will itself be replaced by a new building with a larger ticket hall when the Crossrail scheme is brought into use in 2018. *Below left:* A general view of the station during the early years of the twentieth century.

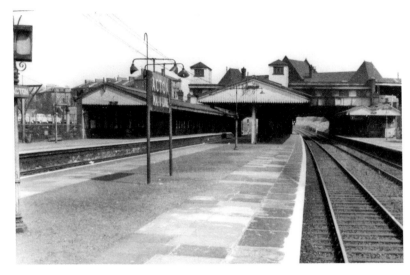

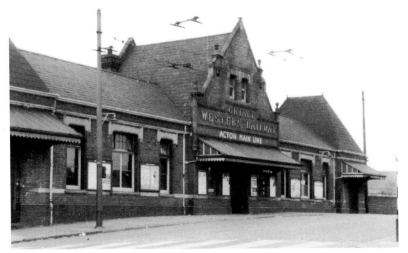

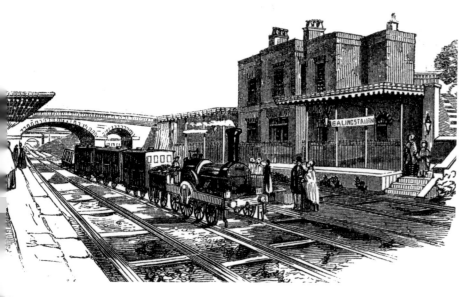

Ealing Broadway

From Acton, the railway continues through a heavily built-up urban landscape to Ealing Broadway (5 miles 56 chains). When opened on 1 December 1838, Ealing had been a wayside station with a split-level building, as shown in the accompanying drawing. The opening of the railway encouraged suburban development and this resulted in a vast upsurge in passenger traffic, which led to much-improved railway facilities at Ealing Broadway. The station was reconstructed with four platforms when the line was quadrupled, and the lower view shows the up and down main line platforms, looking west towards Bristol.

On 1 July 1879 the Metropolitan District Railway opened an extension from Turnham Green to Ealing, which terminated in a District Line station to the north of the GWR platforms. In 1905, the GWR obtained Parliamentary consent for a 4-mile branch from Ealing Broadway to Shepherd's Bush. When eventually opened for passenger traffic on 3 August 1920, the Ealing & Shepherd's Bush branch was worked as an extension of the Central London line, with a service of electric trains between Ealing and Liverpool Street.

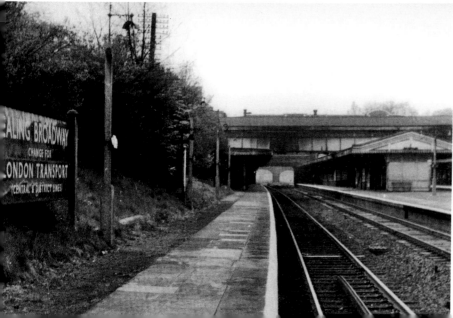

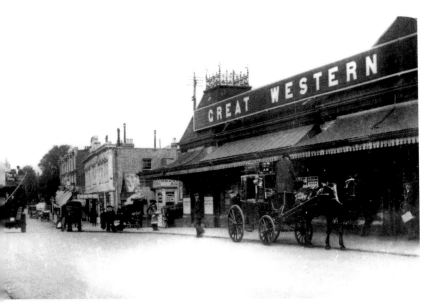 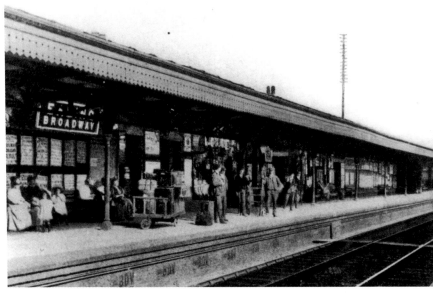

Ealing Broadway: Great Western Architecture

The station buildings were, like their counterparts at nearby Acton, of standard Great Western design, the main street-level buildings being shown in the left-hand illustration. Buildings of this same general type were provided throughout the GWR system from the 1870s onwards, most examples being single-storey, hip-roofed buildings with tall, decorative chimneys and projecting platform canopies. The basic design could be adapted to any site merely by adding or taking away the number of bays, while some stations, including Acton & Ealing Broadway, featured ornate French-style turrets. The platforms were equipped with waiting rooms and other accommodation, as shown in the view to the right, which probably dates from the final years of the Victorian era.

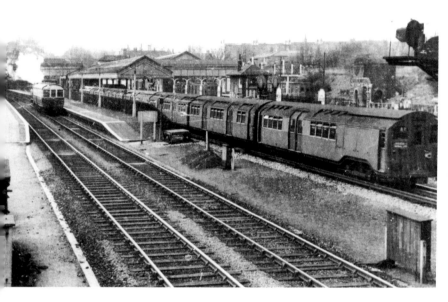

Right: **Ealing Broadway: Main Line & Underground Platforms**
Another view of the station during the 1930s. A lengthy freight train is standing alongside the down relief platform, and a push-pull auto-train can be seen in the up relief platform.

Left: **Ealing Broadway: Main Line & Underground Platforms**
This 1930s photograph of Ealing Broadway station is looking west towards Bristol, with the up and down relief lines in the foreground and the London Transport Underground platforms visible at the rear. A Central Line tube train can be seen to the right. The platforms are numbered from 1 to 9, Nos 1 to 4 being the four Great Western platforms, while platforms 5 and 6 are for Central Line services, and platforms 7 to 9 are the District Line platforms on the northernmost side of the station.

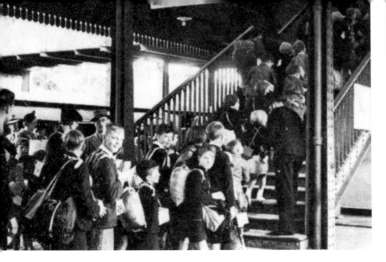

Ealing Broadway: The 1939 London Evacuation Scheme

Ealing Broadway station played a major part in the GWR London Evacuation Scheme, which was put into effect on Friday 1 September 1939 and completed on Monday 5 September – by which time over 600,000 children and adults had been evacuated from London to rural areas that were considered to be safe from German bombing. The evacuation was planned like a military operation, with ten- or twelve-coach trains leaving Ealing Broadway every nine minutes.

The evacuation timetable involved the provision of sixty-three trains per day, comprising one from Paddington, four from Acton and fifty-eight from Ealing Broadway – the latter station being particularly important in view of its direct links to the populous areas of east London via the District and Central Lines. The upper photograph shows evacuee children crossing the footbridge at Ealing Broadway as they leave the London Transport platforms in order to join the GWR evacuation specials on the other side of the station, while the view on the right shows children boarding their train.

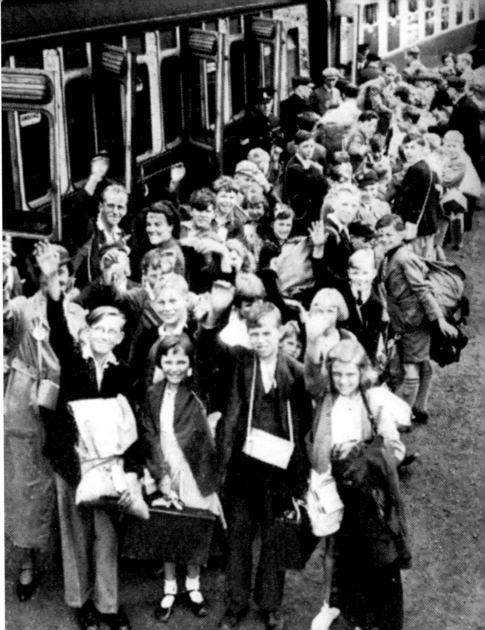

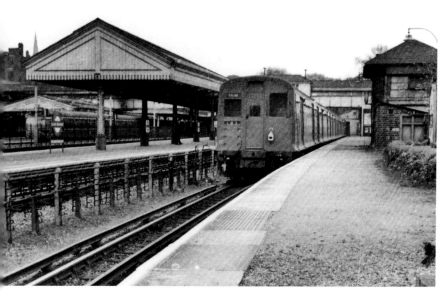

Right: **Ealing Broadway**
A view westwards along the down main line platform, with the high-level station buildings visible in the distance. Platform 1, on the extreme left, and Platform 2, in the centre of the picture, are no longer in use, while the Great Western buildings on the road bridge were replaced as part of a modernisation scheme carried out in 1961/62.

Left: **Ealing Broadway**
A post-war photograph showing Ealing Broadway station around 1964. A District Line train stands in the Underground platforms, while the former GWR platforms can be seen to the left of the picture.

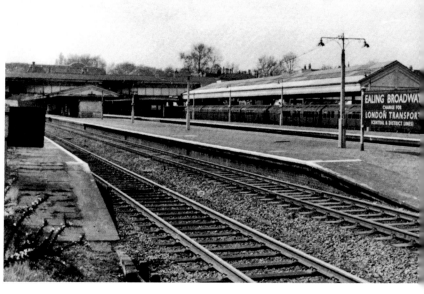

Ealing Broadway

Above: A detailed view, showing the London Transport signal cabin, which was of District Railway origin, and remained in use until November 1952, when a new box was brought into use. *Below*: A random assortment of Edmondson card tickets from Ealing Broadway and other stations in the Great Western London suburban area. Prior to the First World War, GWR tickets had been printed in a variety of different colours, but a much-simplified colour-coded system was introduced in the 1930s. Thereafter, first-class tickets were white, third class tickets were green and excursion tickets were buff. A similar system persisted after nationalisation in 1948.

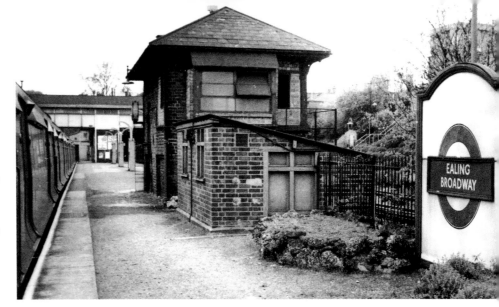

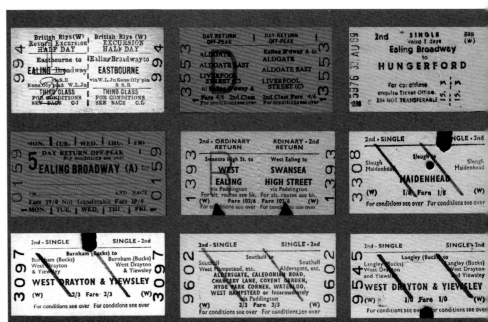

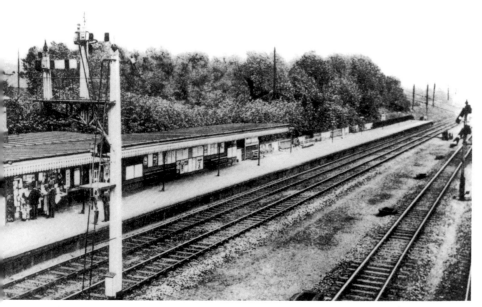

West Ealing

West Ealing, the next stopping place (6 miles 41 chains), is less than a mile from Ealing Broadway. It was opened, as 'Castle Hill Ealing', on 1 March 1871, the present name being adopted in 1899. The station is the junction for local services to Greenford, which diverge northwards just beyond the platforms at West Ealing Junction. Like most of the other stations between Paddington and Didcot, West Ealing has four platforms, the up and down main lines being to the south, while the up and down relief lines are to the north. The relief platforms are staggered – the up relief platform, shown in the upper view, is to the east of the other three platforms. The lower picture shows the street-level station building which, from its appearance, probably dates back to the opening of the station in 1871.

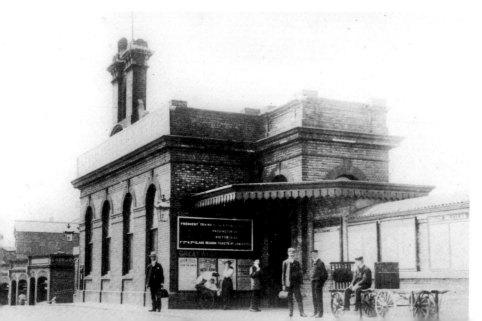

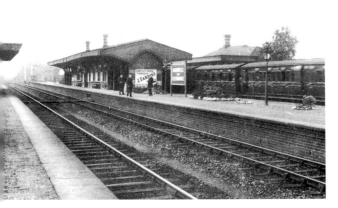

Hanwell & Elthorne

Continuing westwards, down trains reach Hanwell (7 miles 28 chains), which was opened on 1 December 1838. The original stopping place was a simple, two-platform station with very basic wooden buildings perched on the top of an embankment. From these modest beginnings, Hanwell developed into a four-platform station with separate up and down platforms on the main line and relief lines. The main station building is a split-level structure on the up side, while additional buildings are provided on the island platforms. The platform buildings are of timber-framed construction, whereas the main building is part brick and part timber; the platforms are linked by a subway. No goods facilities were ever provided here, Hanwell being a passenger-only station.

Hanwell: The Wharncliffe Viaduct

The Wharncliffe Viaduct (7 miles 49 chains) is sited a short distance to the west of Hanwell station. The viaduct is a brick-built structure with eight elliptical arches and a total length of 297 yards. It carries the GWR main line across the River Brent, and was designed by Brunel in the Egyptian style, with tapered brick piers. The viaduct was widened when the line was quadrupled during the 1870s, with great care being taken to ensure that the new brickwork matched Brunel's original structure. This photograph was taken in the 1980s. The viaduct was named in honour of Lord Wharncliffe, the Chairman of the Lords Committee that had examined the GWR Bill during its passage through Parliament in 1835.

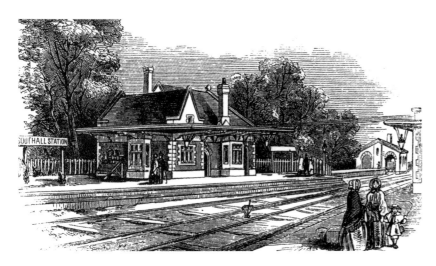

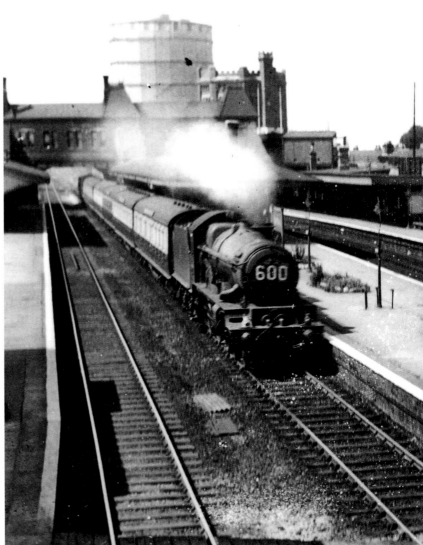

Southall

Southall (9 miles 6 chains) was opened on 1 May 1839. The original station was merely a wayside stopping place, but the opening of the railway encouraged residential development, the first new houses being a cluster of railwaymen's cottages at Southall Green, to the south of the station. By the end of the Victorian period, Southall had grown into a busy outer-suburban station with six platforms, an engine shed, and lavish freight-handling facilities. The station became a junction when the Brentford branch was opened on 1 May 1860.

Southall's first station was a small, Tudor Gothic-style structure, as shown above, but this ornate building was swept away when the GWR main line was quadrupled to provide separate main and relief lines for up and down traffic. Quadruple track was installed between Portobellow Junction and Southall by October 1877, while the additional running lines were extended westwards from Southall to West Drayton in the following year. This major upgrading of facilities resulted in an improved layout at Southall, which henceforth had two pairs of platforms for main line and local traffic. Additional platforms were available to the north and south of the running lines, the northernmost platform being a bay while the southern platform was the outer face of a 'double-sided' island. The lower view shows an express train heading eastwards through the station on the up main line.

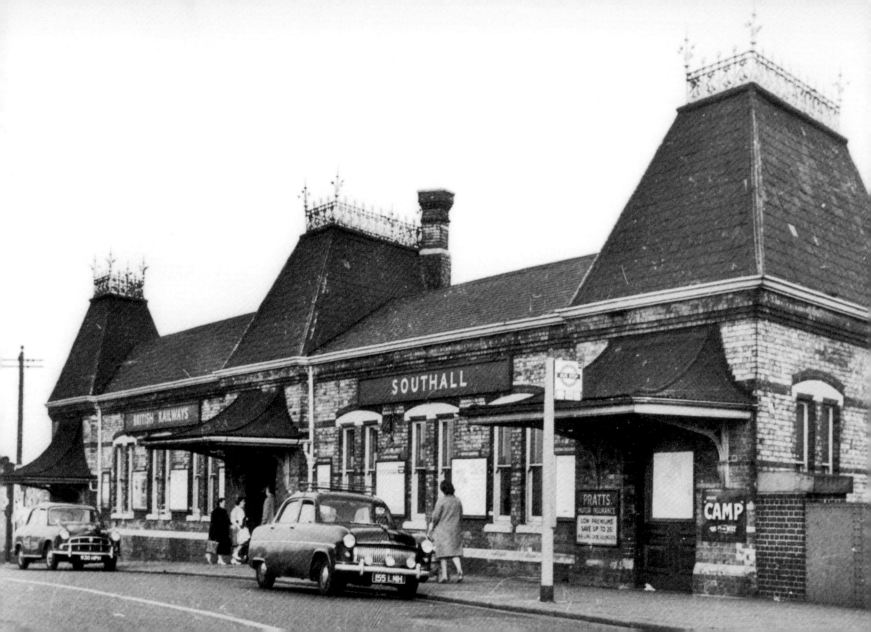

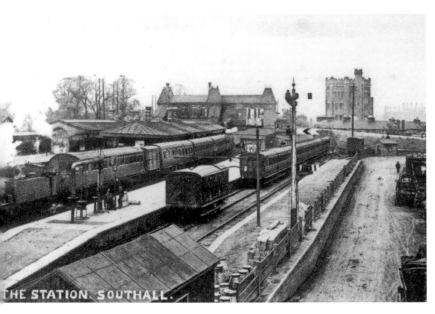 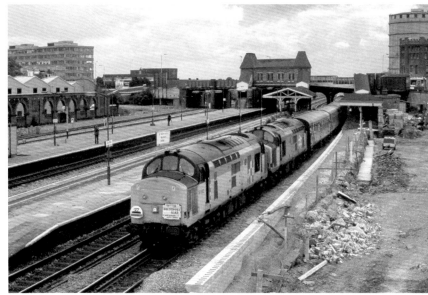

THE STATION. SOUTHALL.

Above: Southall

Above left: A postcard view of Southall station, looking west towards the high-level station buildings around 1912. *Above right*: A considerable amount of building work is in evidence at Southall as class '37' locomotives Nos 37682 and 37685 pass through the station with a railtour from Manchester Piccadilly to Brentford on 22 June 1991. Prior to nationalisation, Southall had been well supplied with goods-handling facilities, the main goods yard, on the up side, being equipped with a large brick goods shed, a cattle dock and three or four sidings for coal and other forms of 'mileage' traffic. The cattle loading dock was sited alongside one of the mileage sidings, while the yard crane was of 6 tons capacity. An array of parallel goods sidings, known as 'The East Yard', was available to the east of the goods yard, and these additional sidings were entered via connections from a further cluster of sidings known as Hanwell Bridge Sidings.

Opposite: Southall: Victorian Architecture

In architectural terms, Southall was a typical Great Western suburban station, its station buildings being standard late Victorian brick structures with hipped roofs, tall chimneys and extensive platform canopies. The main booking office and entrance block was a high-level building situated on the road overbridge at the west end of the platforms, while waiting rooms and other facilities were provided at platform level. The main high-level block boasted three characteristic French château-style towers, while covered stairways descended to platform level.

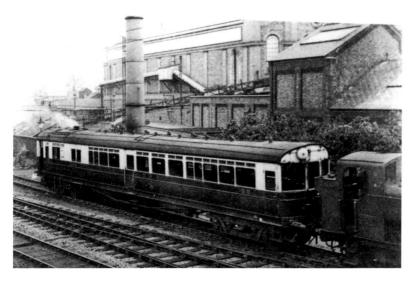

Southall

Left: Steam rail motor car No. 98 at Southall during the 1930s. These self-propelled vehicles were the ancestors of today's multiple unit diesel and electric trains. *Below left:* A general view of the station during the early 1960s. *Below right*: This *c.* 1980 view from the road bridge shows two class '117' units passing on the relief lines. The sidings that can be seen to the left are goods lines that gave access to a marshalling yard known as the West Yard, which was sited to the west of the passenger station and contained twelve parallel sidings. These were known as the up Yard and the down Yard. The up Yard was entered by means of trailing connections from the up direction, whereas the down sidings were entered via similar connections from the down goods line and the down main.

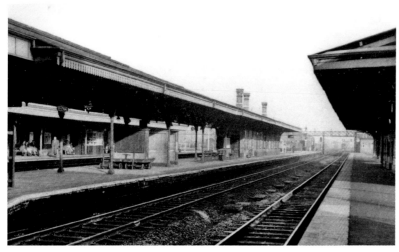

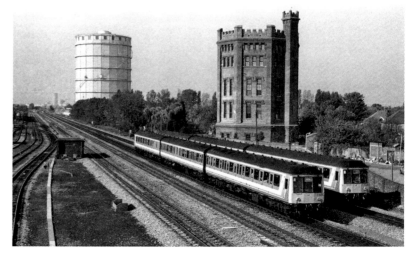

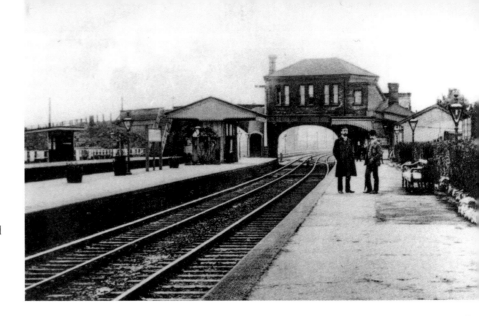

Hayes & Harlington

Hayes & Harlington (10 miles 70 chains), the next station, was opened on 2 May 1864. The facilities provided here consisted of up and down platforms on the main and relief lines, while extensive goods sidings were provided on both sides of the running lines. Station Road is carried across the line on an overbridge at the west end of the station, while sidings branched out to serve Hayes Creosote Works and a number of lineside industries. The main station building was sited on the road bridge, as shown in the accompanying photographs, both of which date from around 1912.

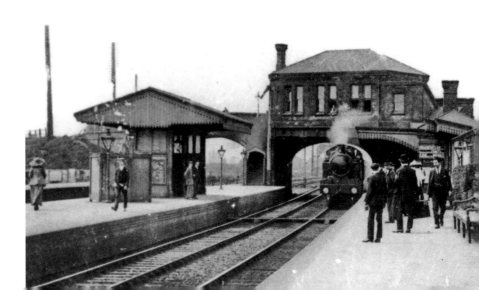

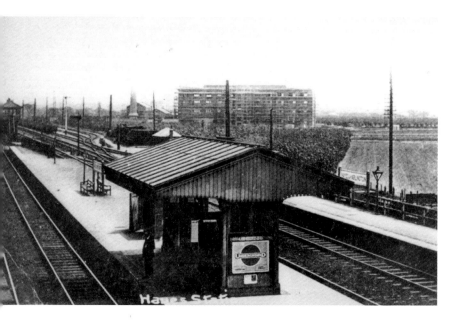

Left: Hayes & Harlington

A detailed view of the shelter on the centre platform, *c.* 1906; the up and down main lines are to the right, while the relief lines are to the left of the picture.

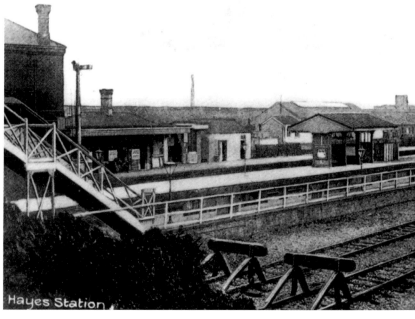

Right: **Hayes & Harlington**

This old postcard view shows the station during the Edwardian period, with the goods shed visible in the background. In 1923, Hayes & Harlington issued 458,640 ordinary tickets and 2,583 season tickets, and this already respectable figure had increased to 556,075 ordinary tickets and 7,381 seasons by 1929. Thereafter, there were over 500,000 passenger bookings per annum throughout the early and middle 1930s, while season ticket sales amounted to around 7,800 a year. In 1938, for instance, 614,354 ordinary tickets were sold, together with 8,415 seasons, while in that same year the station handled 171,746 tons of goods.

Hayes & Harlington

Right: An Edwardian postcard view, looking across the platforms towards the goods shed; the very long building that can be seen in the background was a carriage shed containing seven covered sidings. *Below right:* A general view of the station during the 1960s, looking west towards the road overbridge. The station was extensively rebuilt during the early 1960s, when the old station building on the road overbridge was replaced by a modern building incorporating a booking hall, enquiry office and new staff quarters. At that time the station had a staff of forty-seven, including the stationmaster and seven booking clerks. *Below left:* An unidentified 'Saint' class 4-6-0 runs through Hayes on the up relief line.

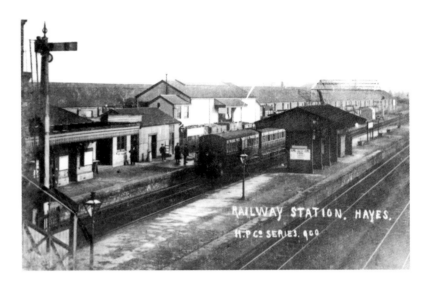

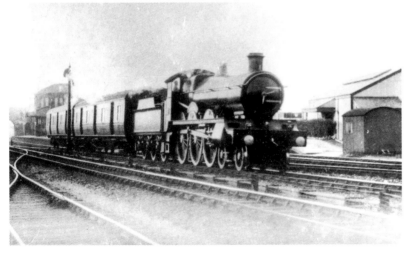

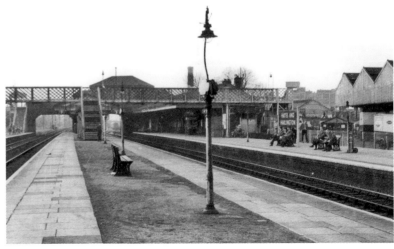

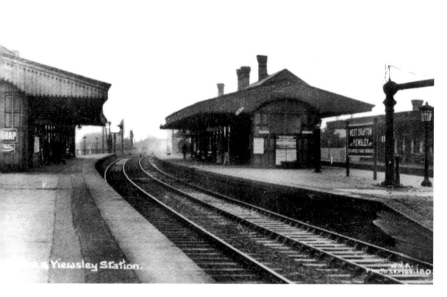
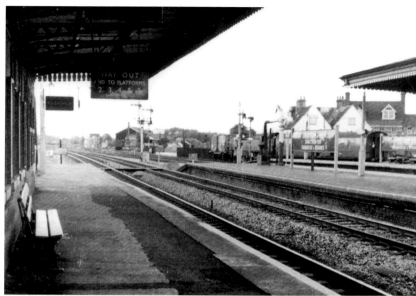

West Drayton & Yiewsley

West Drayton & Yiewsley (13 miles 18 chains), opened on 4 June 1838, was formerly the junction for the Uxbridge Vine Street and Staines West branches, which were opened in 1856 and 1884/85 respectively. In its fully developed form, the station became a busy suburban junction with four platform faces for main line and local traffic, and an additional platform for branch traffic on the north side. The five platforms were linked by an underline subway, and the station was equipped with a range of standard GWR yellow-brick buildings with tall chimneys and capacious platform canopies.

 The main booking office was located in a low-level building on the north side of the line, which boasted a tall 'lantern' or heightened roof that let in additional light and created an atmosphere of spaciousness in the booking hall. The island platforms were equipped with standard brick buildings incorporating waiting rooms and lavatories, while the side platform on the down side had a small booking office for the convenience of travellers entering the station from the south (West Drayton) side. The left-hand view is looking east towards Paddington from the up relief platform, while the right-hand picture is looking westwards from the down main line platform.

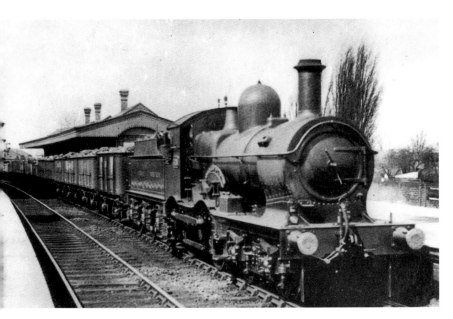

West Drayton & Yiewsley

Above left: An unidentified 'Duke' class 4-4-0 hauls a coal train through West Drayton station on the up relief line during the 1930s. *Above right*: The 12.10 p.m. Reading to Paddington Network South East service heads eastwards on the up main line at West Drayton on 22 June 1991. This was an all-stations service as far as Slough, from where it ran non-stop to Paddington. The train is a hybrid three-car set consisting of class '121' single unit railcar No. 55031, together with a class '101' driving trailer composite and a class '117' driving motor brake second – an odd combination that underlines the versatility of the first generation multiple units! In January 1963, West Drayton was the scene of a robbery in which £700 was stolen by a gang of thieves who had stopped a train by turning on the guard's hand brake. Seven months later, this same gang carried out the Great Train Robbery.

Left: West Drayton & Yiewsley

Class '50' locomotive No. 50030 *Repulse* speeds past West Drayton with the 7.46 a.m. Oxford to Paddington service on 6 November 1986. This important-looking ten-coach train was in fact a local working that called at all stations between Oxford and Reading, and then ran non-stop to Paddington.

Right: West Drayton & Yiewsley

Class '59' locomotive No. 59102 heads westwards along the down main line with an empty ARC stone train on 22 June 1991.

In 1932, West Drayton issued 529,819 ordinary tickets and 7,643 seasons, rising to 579,158 ordinary tickets and 8,402 seasons by 1937; these figures suggest the station may have been handling up to 1 million passengers a year during the later 1930s, while in more recent years this busy station has generated around 1½ million passenger journeys per annum.

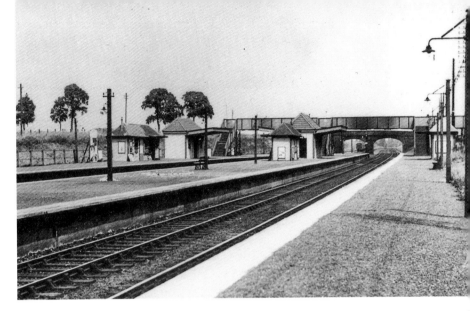

Iver

On leaving West Drayton, trains head westwards along dead-level alignments and, having crossed the county boundary between Middlesex and Buckinghamshire, they soon reach Iver (14 miles 60 chains), which is a little over 1½ miles further on. Iver is a comparatively recent addition to the railway network, and when first opened on 1 December 1924 it was regarded as little more than a staffed halt, its traffic receipts being included with those of Langley. As shown in the upper photograph, Iver's facilities were fairly basic, but it was soon generating significant amounts of passenger traffic; a small goods yard was opened in 1927, and the station also handled private siding traffic.

The colour photograph shows class '117' unit No. L421 passing Iver on the down relief line with the 12.20 p.m. Paddington to Maidenhead Network South East service on 22 February 1990; this three-car set comprised motor brake second No. 51359, trailer composite No. 59511 and motor brake second No. 51401.

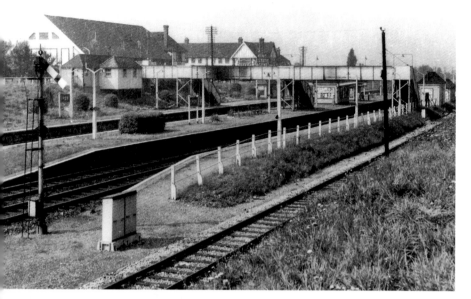

Iver

In 1933, Iver issued 74,364 ordinary tickets and 3,970 season tickets, rising to 88,766 ordinary tickets and 3,969 seasons in 1938, while in 2011 this small station was generating over 500,000 passenger journeys per annum. The upper view provides a general view of Iver, looking west towards Bristol during the 1960s; the single line that can be seen in the foreground is the up goods loop.

The colour view shows class '59' locomotive No. 59005 *Kenneth J. Painter* heading westwards past Iver on 22 February 1990 with the 2.47 p.m. Acton to Merehead stone empties. The photographs reveal that Iver is situated in the first area of open countryside that the Great Western main line passes through on its way out of London – although even this respite from urban sprawl is brief, as Slough is not far away!

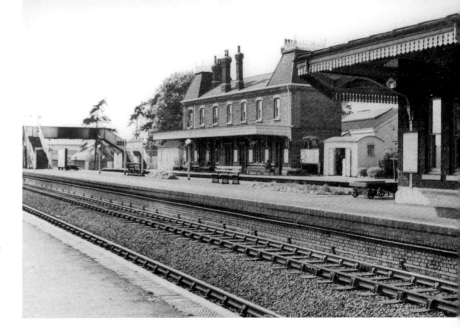

Langley (Bucks)

Langley (16 miles 18 chains) was opened as Langley Marsh in 1846, and its subsequent history is similar to that of other stopping places on this part of the GWR route. The station eventually developed into a four-platform suburban station, with its main station building and goods yard on the up side. The platforms are linked by a plate-girder footbridge, while the station building is a two-storey version of the usual Great Western standard design. These two photographs are both looking west towards Bristol during the 1960s.

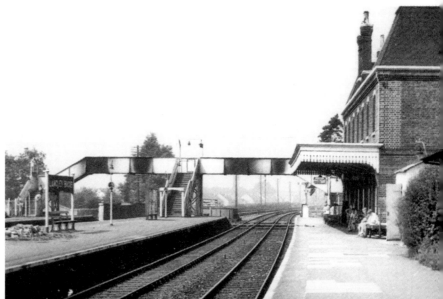

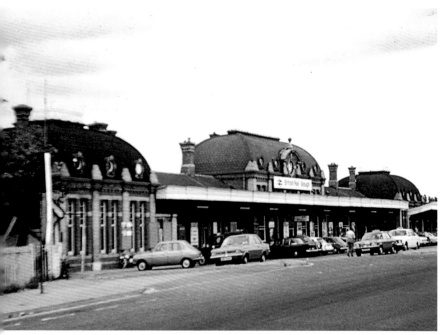

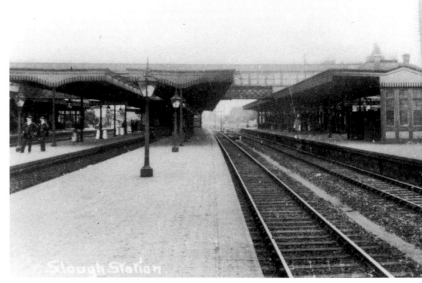

Above: Slough

Continuing westwards along the more or less dead-flat Great Western route, trains soon arrive at Slough (18 miles 60 chains), which has been a junction since the opening of the Windsor branch on 8 October 1849. The station once had four through platforms and three bays, including a bay for the Windsor branch, but the number of platforms has now been reduced to five. The station buildings here are of particular interest, being deluxe versions of the usual standard GWR design, the main building on the down side being adorned with decorative pilasters and an ornamental roof, as shown in the colour photograph. The old postcard view is looking east towards Paddington, with the up and down main lines to the right of the picture.

Opposite: Slough

This view shows class '50' locomotive No. 50043 *Eagle* approaching the station on the up main line on 3 August 1978. Amusingly, when the GWR was first opened in 1838 the company was forbidden to erect a station at Slough, in view of the proximity of Eton College – the provost having persuaded himself that the new mode of transport would be injurious to the morals of the school. To overcome this difficulty, the trains stopped to pick up and set down on the open track, without the benefit of platforms or station buildings! Tickets were issued at a nearby inn until, in 1840, the company was permitted to erect a proper station.

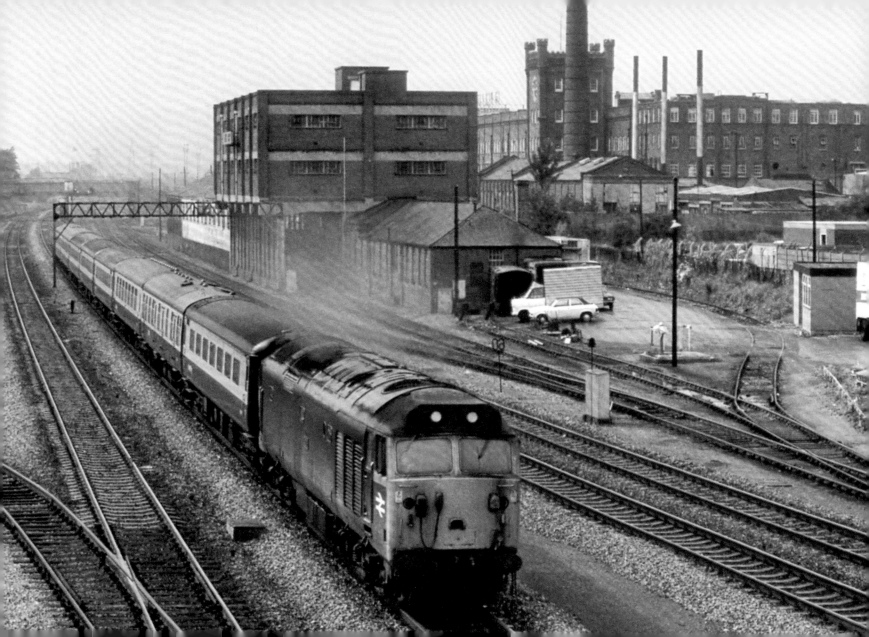

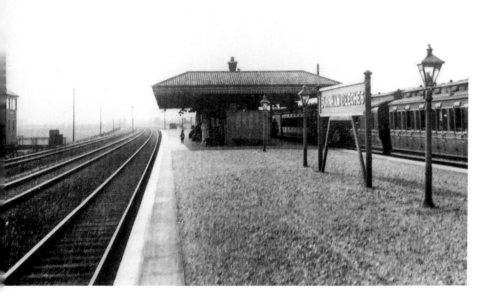

Burnham (Bucks)

Still heading westwards, trains reach Burnham (20 miles 77 chains), which was opened as Burnham Beeches on 1 July 1899, and known as 'Burnham (Bucks)' from 1930 until 1975. Intended essentially for suburban traffic, Burnham is unusual in relation to other stations of the GWR main line insofar as it has just one island platform between the up and down relief lines – no platforms having been considered necessary on the main line. The station building boasts a large, overhanging roof in lieu of a canopy, as shown in the accompanying illustrations. The upper photograph was taken around 1912, whereas the lower view dates from the 1960s.

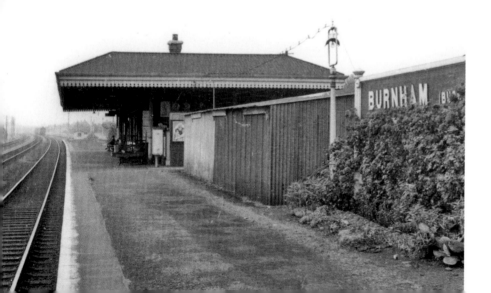

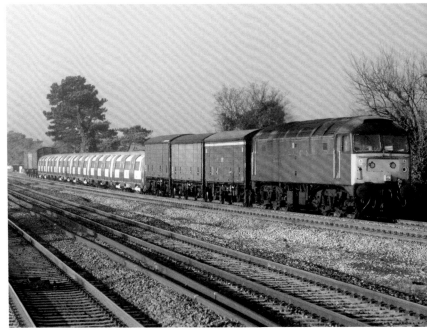

Taplow

When the first section of the GWR main line was opened from Paddington on 4 June 1838, it terminated at a temporary station known as 'Maidenhead'. However, on 1 September 1872 this earlier station was replaced by a new station at Taplow, about a quarter of a mile to the east. This still-extant stopping place (22 miles 37 chains) has four platforms and a range of red-brick buildings that can be seen, in some respects, as prototypes of the standard Great Western station design – although the fenestration and other details at Taplow differ in relation to those found at later stations. The older picture provides a general view of the station, looking east towards Paddington during the 1960s, while the colour photograph shows class '47' locomotive No. 47575 *City of Hereford* approaching Taplow on 26 January 2000, while hauling a trainload of newly built London Underground Northern Line tube stock from GEC Alsthom at Washwood Heath.

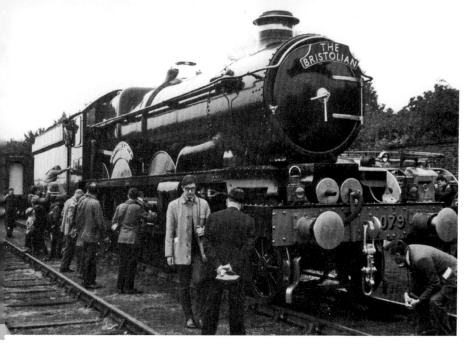

Taplow: Great Western Society Open Days

Taplow has a particular claim to fame in terms of the railway preservation movement, insofar as it was the setting for a hugely successful Great Western Society Open Day on 17 September 1966, which attracted over 7,000 people and was the precursor of further open days in the ensuing years. *Above*: Admiring crowds cluster around 'Castle' class 4-6-0 locomotive No. 4079 *Pendennis Castle* during the 1966 GWS Open Day. *Below*: The highlight of the day was the arrival of 'Manor' class 4-6-0 No. 7808 *Cookham Manor* with an excursion train from Birmingham, which had travelled via the 'New Line' and entered Taplow from the London direction.

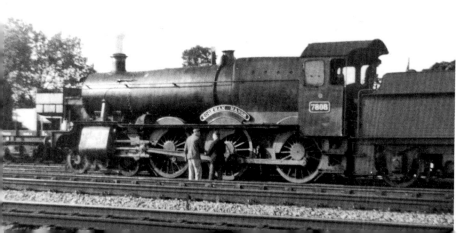

Maidenhead

Above: This contemporary print shows Maidenhead's first station, which, as pointed out above, was opened as Taplow in 1838. This station was on the Taplow side of the River Thames, and well over a mile from Maidenhead, but it served both Taplow and Maidenhead until 1 August 1854, when a second station known as 'Maidenhead Boyne Hill' was brought into use on the other side of the river. *Below:* A third station was opened on 1 November 1871 but, as a result of quadrupling, the 1871 station was itself replaced by the present Maidenhead station (24 miles 19 chains), which is, in effect, the fourth to bear the name. It has five platforms and a range of standard GWR hip-roofed station buildings. These are attractively constructed of yellow brickwork with red-brick dressings, and at the time of writing their canopies and other architectural features are largely intact – although the station will undergo significant modifications in connection with electrification and the introduction of Crossrail services, which will terminate here.

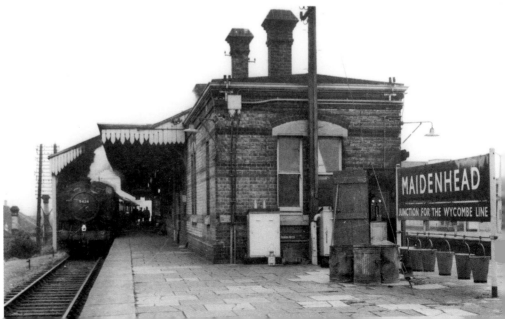

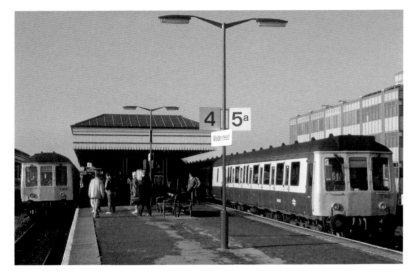

Maidenhead: Platform Scenes

Left: Pressed Steel class '117' unit No. L415, formed of motor brake second No. 51351, trailer composite No. 59503 and motor second No. 51393, waits in Platform 5 with the 10.14 a.m. Maidenhead to Paddington 'all stations' service, while set No. L425, comprising motor second No. 51405, trailer composite No. 59515 and motor brake second No. 51363, has just arrived with the 9.54 a.m. Reading to Paddington service. *Below left*: Hawksworth '94XX' class 0-6-0PT No. 9463 takes water from the water column on Platform 3; the locomotive is hauling a very short freight consisting of just two wagons and a Great Western 'Toad' brake van. *Below right:* A rear view of Maidenhead signal box, probably photographed around 1928.

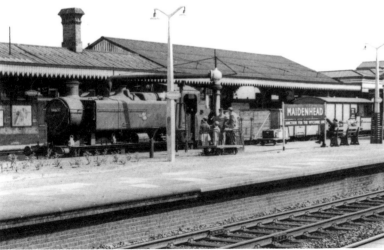

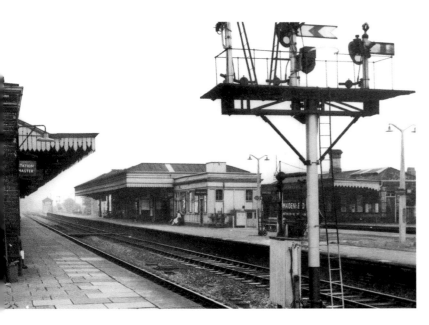

Left: Maidenhead
A general view of Maidenhead station, looking eastwards along the down relief platform during the 1960s.

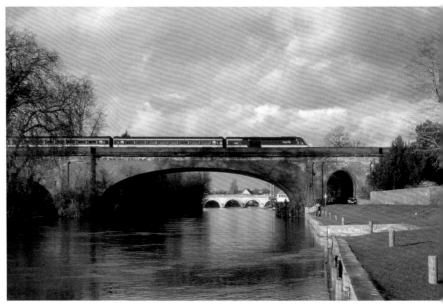

Right: Maidenhead
Brunel's famous flat-arched bridge across the Thames, to the east of Maidenhead station, has two main arches, each with a span of 128 feet and a rise of only 24 feet 6 inches to the crown. Critics predicted that the flat-arches would collapse as soon as the centring was removed, and the engineer was ordered to leave the timber centres in place until the bridge had properly settled. However, Brunel eased the centres on 8 October 1838, but few people knew this until, some nine months later, the bridge a stood firm after the redundant centres had been blown down during 'a great storm of wind and rain'.

Maidenhead: Trains at Waltham St Lawrence

Above: Class '66' locomotive No. 66593 is pictured on the down relief line at Waltham St Lawrence (between Maidenhead and Twyford) while working the 8.58 a.m. Southampton to Lawley Street Freightliner service on 27 July 2007. The photograph was taken from a footbridge in the fields near Shottesbrooke. The bridge in the background is Chalkpit Bridge, on the bridleway between Waltham St Lawrence and Knowl Hill. *Below left:* Class '47' locomotive No. 47587 *Ruskin College Oxford* passes White Waltham, to the west of Maidenhead, with the 11.10 a.m. Paddington to Oxford Network South East service on 6 January 1991. Superb winter sunlight and a complete set of matching Network South East vehicles make an attractive picture, though it is a pity that one of the coaches is in need of a visit to the washing plant. *Below right:* Class '50' locomotive No. 50036 *Victorious* passes Waltham St Lawrence as it accelerates away from Twyford station with the 7.19 a.m. Didcot to Paddington Network South East service on 2 June 1989.

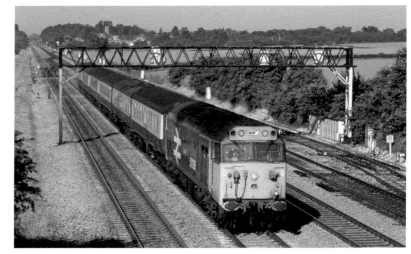

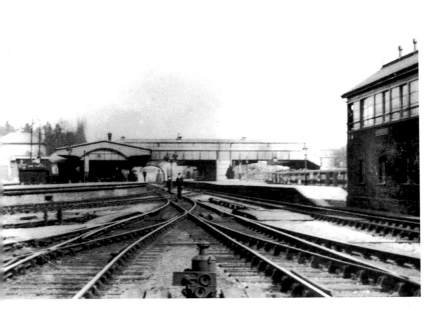 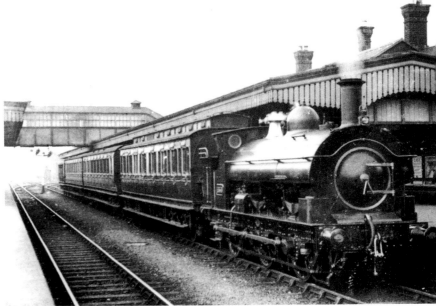

Twyford

From Maidenhead, the quadruple-tracked route climbs imperceptibly on a rising gradient of 1 in 1320, Brunel's superbly engineered railway being virtually dead-level between Paddington and Chippenham. Twyford, the next station (31 miles 1 chain), was opened on 1 July 1839, and its history echoes that of other suburban stations en route to Didcot. The station was elevated to junction status following the opening of the Henley-on-Thames branch on 1 June 1857, while, as a result of quadrupling, the station evolved into a five-platform stopping place with up and down main line and relief line platforms, and an additional bay for Henley branch trains on the north side. The left-hand view is looking east towards Paddington during the early 1900s, with Twyford West Signal Box visible to the right. The picture to the right shows an unidentified '1076' class outside-framed saddle tank in the up relief platform.

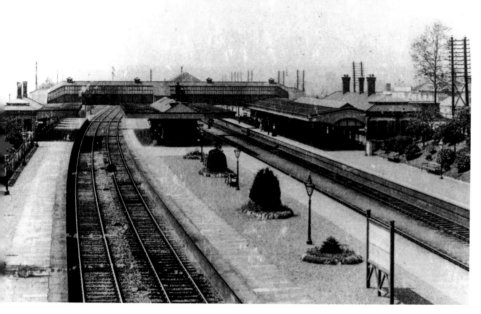

Twyford: Then and Now

These two contrasting views are both looking westwards from the road overbridge at the Paddington end of the station, the sepia postcard being from the early 1900s whereas the colour photograph was taken on 3 August 1978. There had been few obvious changes in the intervening seventy years, although the up and down main line platforms that can be seen on the extreme left had been taken out of use in connection with high-speed realignment work, and the goods yard sidings (out of sight behind the footbridge) had been lifted in 1965 to provide additional car parking spaces.

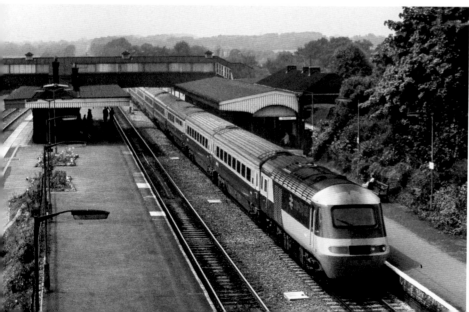

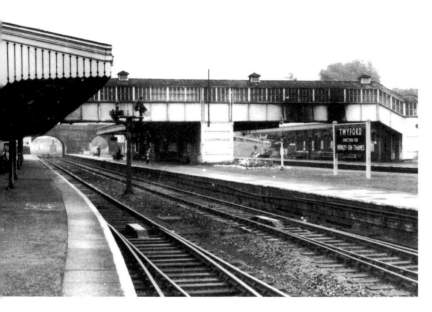

Right: Twyford

'Grange' class 4-6-0 locomotive No. 6861 *Crynant Grange* enters Twyford station on the down relief line.

Left: Twyford

A general view of Twyford station, looking east towards Paddington during the 1960s. The up and down relief lines can be seen in the centre of the picture, while the turnout in the foreground gives access to the Henley-on-Thames branch, and is used by through workings between Henley and Paddington.

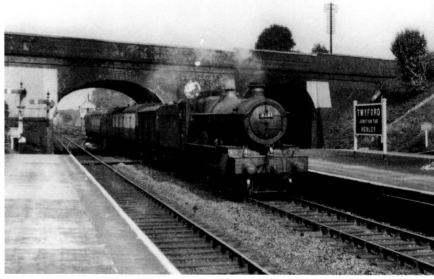

Right: **Twyford: Passenger Trains in Ruscombe Cutting**
An HST set headed by power car No. 43017 passes Ruscombe (29 miles 38 chains) on the up main line with the 6.48 a.m. 'Bristolian' service from Weston-super-Mare to Paddington on 17 April 2008. Although most First Great Western coaches had acquired blue livery by that time, the catering car (third from the front) is still in green livery.

Left: **Twyford: Passenger Trains in Ruscombe Cutting**
The driver of class '165' unit No. 165126 gives the windscreen a good clean as he accelerates away from Twyford station on the up relief line with the 9.37 p.m. Oxford to Paddington First Great Western service on 1 May 2012. This side view clearly shows the small first class section at the leading end of the unit.

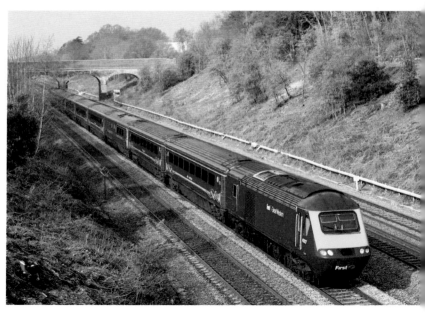

Left: Twyford: Freight Train in Ruscombe Cutting

Freightliner class '66' locomotive No. 66524 hurries along the up relief line at Ruscombe on 1 May 2013, as it works the 7.01 a.m. Stoke Gifford to Thorney Mill stone train, utilising a rake of ex-Bardon hopper wagons.

Right: Twyford: Passenger Train in Ruscombe Cutting

A six-car formation, composed of class '165' unit No. 165128 and class '166' unit No. 166220, passes Ruscombe with the 9.25 a.m. Oxford to Paddington First Great Western special service on 1 May 2013.

Reading: Sonning Cutting

As westbound trains approach Reading they pass through the impressive Sonning Cutting, 2 miles long and up to 60 feet deep, which is spanned by two bridges at its deepest part. The left-hand picture shows class '60' locomotive No. 60065 *Kinder Low* passing through the cutting with the 10.12 a.m. Micheldever to Ripple Lane empty oil train on 26 March 1992. The right-hand view shows 3-car class '117' unit No. L424, comprising motor second No. 51404, trailer composite No. 59514 and motor brake second No. 51362 near Woodley (32 miles 60 chains) while working the 8.45 a.m. Didcot to Paddington service on Sunday 14 June 1987.

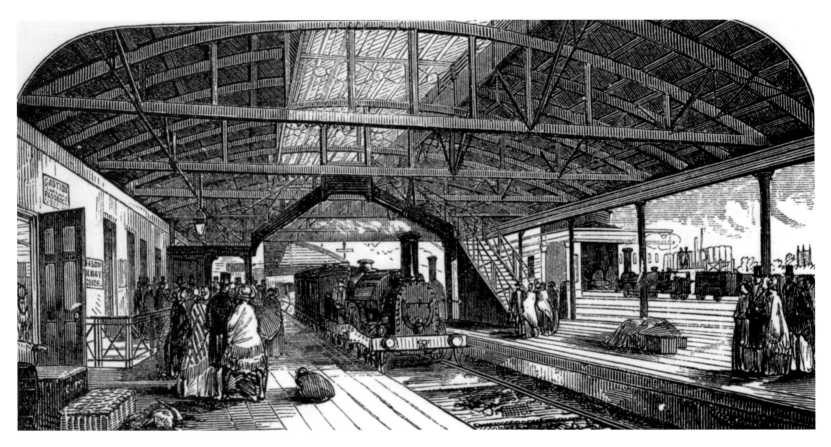

Reading: The Original Station

Reading was, from the very start, a major traffic centre on the GWR main line, its importance being enhanced by the opening of the Berks & Hants lines to Hungerford and Basingstoke on 21 December 1847 and 1 November 1848 respectively. When first opened in 1840, Reading had featured one of the Great Western's curious 'single-sided' station layouts, with separate platforms for up and down traffic on the down side of the line. There were two cavernous wooden train sheds, together with separate station buildings for up and down traffic, both of these being two-storey hip-roofed structures. The main illustration provides a glimpse inside one of the wooden train sheds around 1850.

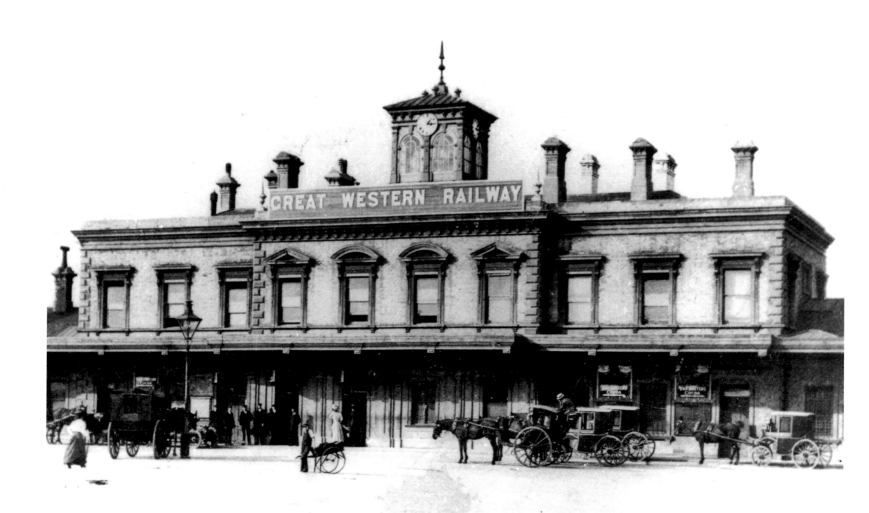

Right: Reading: Platform Scenes

Reading station underwent several changes during the Victorian period, and by the end of the nineteenth century it had been rebuilt with four lengthy through platforms and a number of terminal bays, which, in recent years, have been numbered in logical sequence from 1 to 10. The platforms were covered by extensive canopies with characteristic GWR 'V-and-hole' valancing, as shown in the upper picture, which is looking east towards Paddington on 3 July 1952. The lower picture shows Platform 4 during the BR period on 4 July 1951.

Opposite: Reading: The Main Station Building

A much-improved two-storey station building was subsequently built, although, as shown in the upper view, the unconventional single-sided track layout was retained for many years. From an Edwardian postcard, a detailed view of the main station building is seen, which was an Italianate structure with a low-pitched hipped roof surmounted by a raised lantern or belvedere. The building was constructed of yellowish-grey brickwork, with stone dressings, while further visual interest was provided by a profusion of ornate chimney stacks and decorative window heads. This distinctive building is now a popular pub known as The Three Guineas.

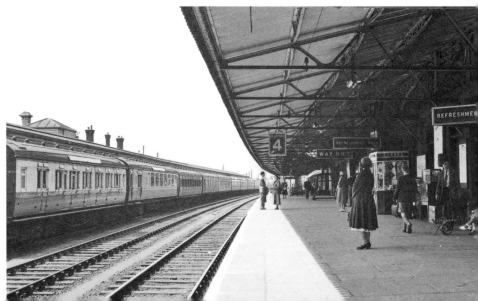

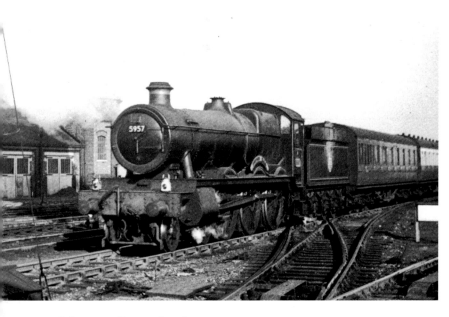

Right: **Reading: Diesel Power**
An HST set headed by power car No. 43003 pauses in Platform 5 at Reading in July 2002. A Virgin 'Voyager' unit can be seen in the adjacent Platform 5.

Left: **Reading: Steam Power**
'Hall' class 4-6-0 No. 4931 *Hanbury Hall* at Reading with an up express in July 1951.

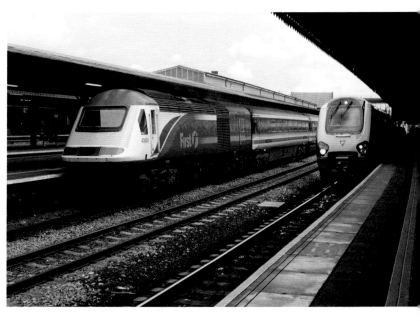

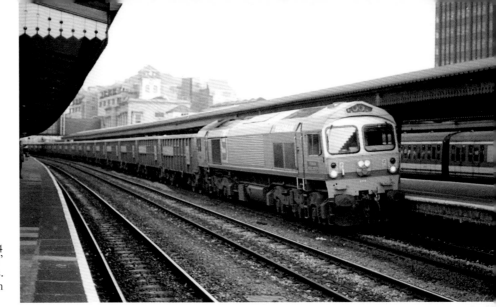

Reading

Above: Class '59' locomotive No. 59003 waits alongside Platform 4 with a train of empty stone wagons in April 1994. *Below:* Class '33' locomotive No. 33107 stands in Platform 2 during the early 1980s. Platform 2 is one of three terminal bays at the west end of the main down platform.

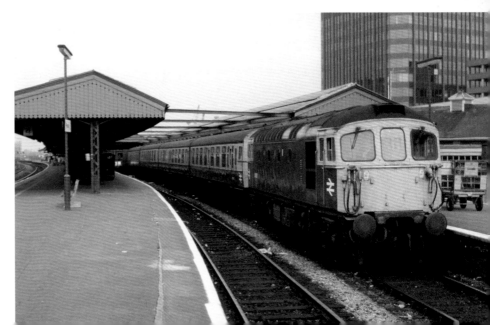

Left: Gas Turbine Power at Reading

In 1972, BR introduced a gas turbine-powered tilting train, known as the APT-E (Advanced Passenger Train Experimental), but this prototype unit was immediately 'blacked' by the train drivers' union. The APT-E was subsequently tested on the Great Western main line, and on 10 August 1975 it reached a speed of 152 mph on the dead-level stretch between Reading and Swindon. The picture shows the APT-E at Reading in August 1975.

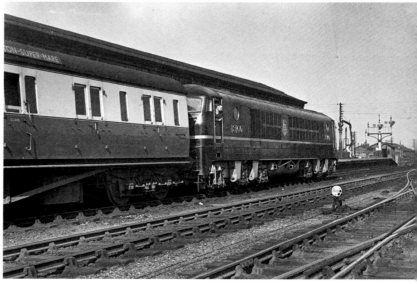

Right: Gas Turbine Power at Reading

Although gas turbines are now widely employed by the Royal Navy, British gas turbine locomotives never progressed beyond the experimental stage. In 1949, BR took delivery of two gas turbine locomotives that had been ordered for trial purposes by the GWR. One of these was No. 18100, which was photographed at Reading on 17 May 1952 while working a Paddington to Weston-super-Mare express. No. 18100 was converted into an electric locomotive in 1959.

Reading: Steam and Diesel Power

The upper view shows 'Hall' class 4-6-0 No. 4931 *Hanbury Hall* with an up express at Reading on 1 July 1951, while the lower view shows an HST set headed by power car No. 43043 in Platform 4 with a down Inter City working. Reading has always been one of the busiest stations on the Great Western system; in 1937, it issued 606,165 ordinary tickets and 12,454 seasons, while by the mid-1980s Reading was generating around 10.8 million passenger journeys per annum, rising to 15.25 million passenger journeys by 2012. At the time of writing the station is being extensively rebuilt, with four new platforms on the north side and new station buildings of striking and futuristic design.

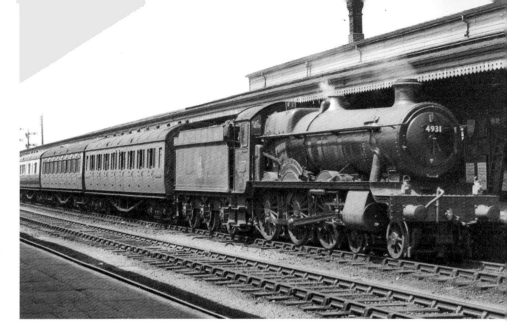

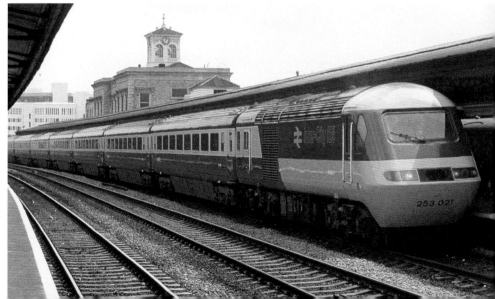

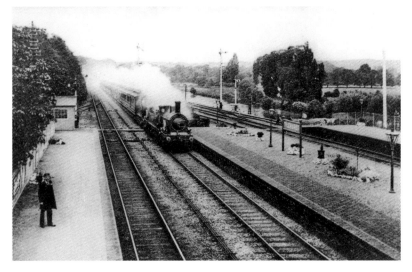

Tilehurst

On leaving Reading, trains pass Reading East Junction, at which point the Berks & Hants route diverges south-eastwards from the main line. Continuing westwards along the original GWR route, trains reach the suburban station at Tilehurst (38 miles 51 chains), which is built virtually on the banks of the Thames, and was opened on 10 April 1882. Four platforms are provided, and the red-brick station buildings are of the usual Great Western standard design. *Left:* An eastbound express on the up main line. *Below left:* Looking westwards along the up main platform. The pictures date from the early years of the twentieth century. *Below right:* A detailed view of the booking office on the down side which is, perhaps surprisingly, of stone construction.

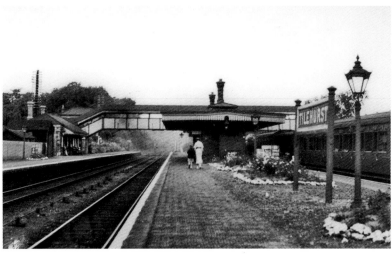

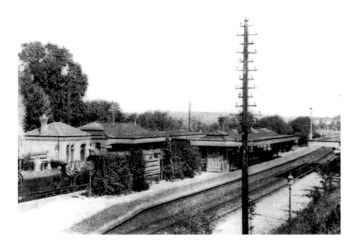

Pangbourne

Heading north-westwards beside the River Thames, the quadruple-tracked line continues for a further 3 miles to Pangbourne (41 miles 43 chains), another typical Great Western suburban station, with standard, red-brick buildings of the now-familiar type. The picture above provides a view of the station around 1912, while the colour photograph, taken on 28 April 1993, shows a diesel multiple unit leaving Pangbourne on the down relief line while forming the 5.20 p.m. Paddington to Banbury service. The train itself is a hybrid formation, comprising class '121' single unit railcar No. 55029 (leading) class '101' driver trailer composite No. 54396 and class '101' motor brake second No. 51221. A class '165' unit can be glimpsed in the distance as it passes through the station on down main line.

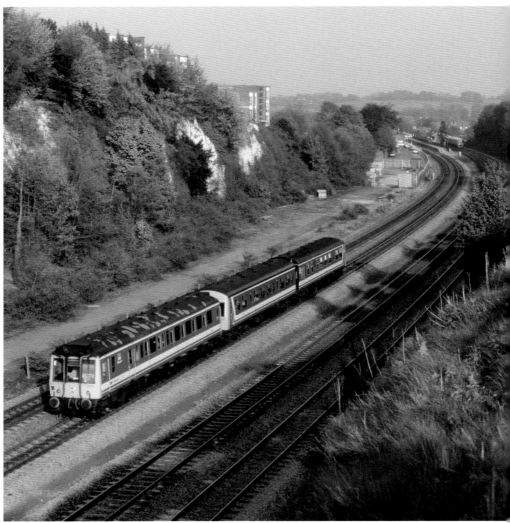

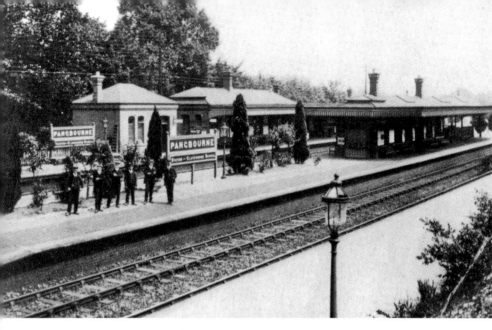

Pangbourne

Above: A further view of Pangbourne station during the early 1900s; the platforms here are linked by an underline subway. When opened on 1 June 1840 Pangbourne had been a modest, two-platform station with a Tudor Gothic-style station building, similar to the one illustrated on page 35. *Below*: A selection of tickets issued at Reading, Maidenhead, Tilehurst and Pangbourne, including a platform ticket, three 'Multiprinter' machine-issued singles, three conventional Edmondson singles and a cheap day return.

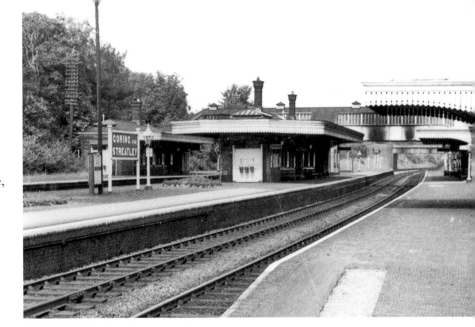

Goring & Streatley

Having crossed the county boundary between Berkshire and Oxfordshire, westbound trains reach Goring & Streatley (44 miles 60 chains). Although this station was opened on 1 June 1840, the present station is of late Victorian origin – the layout having been remodelled when the line was quadrupled in the 1890s. The upper picture shows the station around 1912, the up and down main lines being to the left, while the relief lines are to the right. The lower view shows class '67' locomotive No. 67006 *Royal Sovereign* as it approaches Goring in clear morning light while working the Kingfisher Railtours 'Golden Arrow' railtour from Taunton to Folkestone on 12 April 2008; 'Battle of Britain' class 4-6-2 No. 34067 *Tangmere* would take over the tour at Willesden.

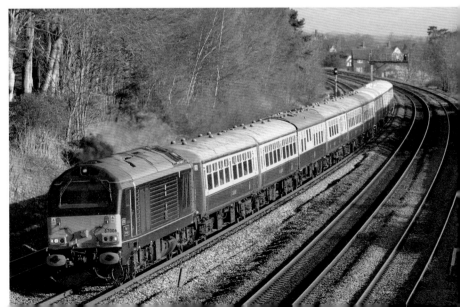

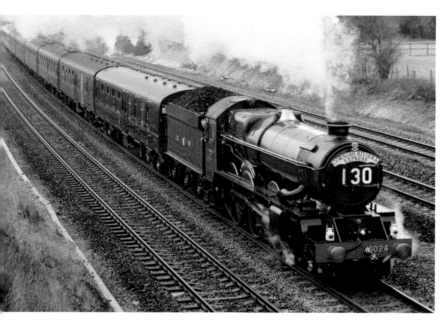

Right: **Goring & Streatley**
A foggy autumnal scene as class '50' locomotive No. 50050 *Fearless* speeds towards Goring with the 1.15 p.m. Oxford to Paddington service on 5 November 1983.

Left: **Goring & Streatley**
'King' class 4-6-0 No. 6024 *King Edward I* heads westwards along the up relief line, near Goring at the head of the Paddington to Paignton 'Silver Dart' railtour on 5 February 1995. Designed by C. B. Collett and introduced in 1927, the 'Kings' were the Great Western's most powerful express passenger locomotives, but their weight meant that they could only travel on lines classed as 'dotted red' routes under the GWR colour-coded weight restriction system. Three examples have been preserved.

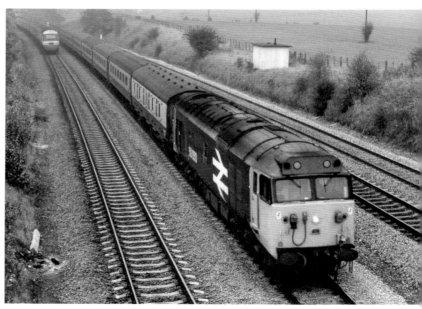

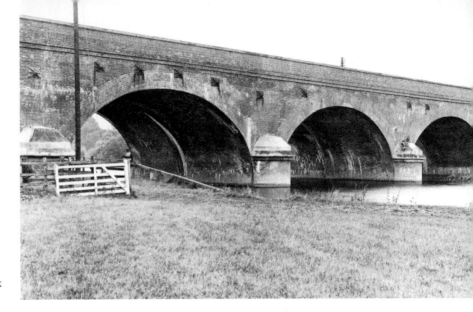

Goring & Streatley: Gatehampton and Moulsford Bridges

There are two railway bridges across the Thames in the Goring area, Gatehampton Farm Bridge being to the east of the station, while Moulsford Bridge is sited some 3 miles to the west. The bridges are of similar design, with four elliptical arches; both bridges were widened in the 1890s when the line was quadrupled. The upper view shows Gatehampton Viaduct during the early years of the twentieth century, while the colour photograph shows Moulsford Viaduct from the foredeck of narrowboat *Towy* in 1984.

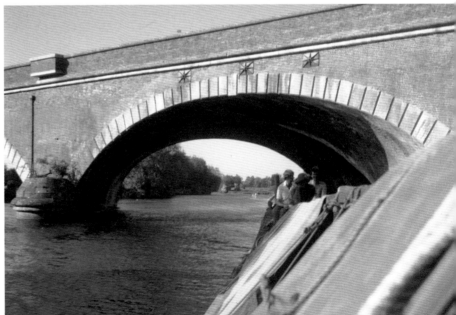

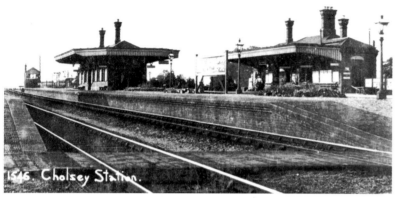

1646 Cholsey Station.

Cholsey & Moulsford

Left: Cholsey & Moulsford station (48 miles 37 chains) was opened on 29 February 1892, when it replaced an earlier station, known as 'Wallingford Road', that had been sited about three quarters of a mile to the east. Five platforms are provided, the main lines being on the south side, while the relief lines are to the north; an additional platform serves the Wallingford branch. The red-brick station buildings are of standard GWR design, as shown in this *c.* 1912 postcard view. *Below left:* The Wallingford branch platform, looking towards Bristol. *Below right:* A detailed view of the 'island' building on platforms 2 and 3 (the canopies have now been removed). In the mid-1930s, this outer-suburban station issued around 26,000 ordinary tickets and 200 seasons per annum, while by 2011 it was generating around 200,000 passenger journeys each year. The goods yard was closed in July 1970.

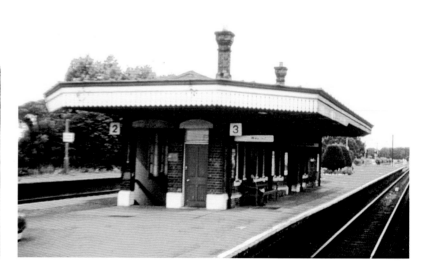

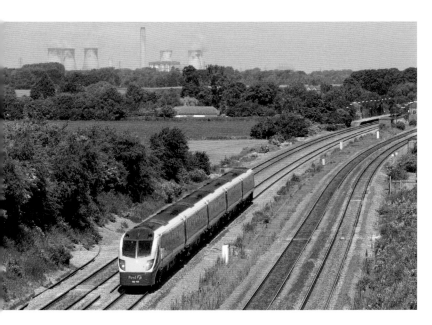

Right: Cholsey & Moulsford

Class '66' locomotive No. 66192 passes Cholsey & Moulsford on the down relief line while working the 2.38 p.m. Dagenham Dock to Didcot Ford car train on 4 September 2013.

Left: **Cholsey & Moulsford**

This panoramic view shows the eastern approaches to the station on 15 June 2004. Class '180' unit No. 180109 is speeding towards Paddington on the up main line with the 9.29 a.m. Cheltenham to Paddington First Great Western service, while the relief lines can be seen to the right of the picture.

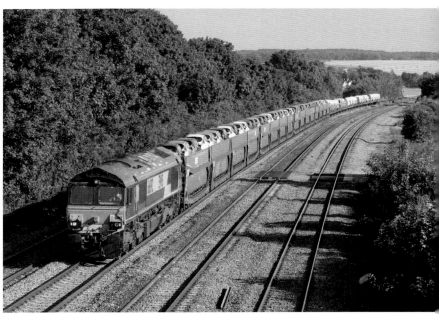

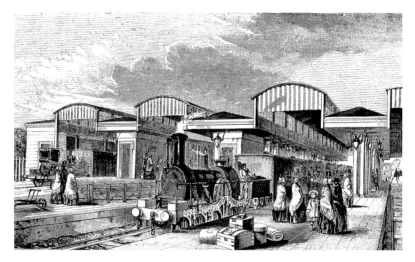

Didcot

At the start of the Victorian period, Didcot (53 miles 10 chains) was merely a village, but its fortunes were utterly transformed by the opening of the Great Western main line on 1 June 1840. The Oxford line was opened on 12 June 1844 and, thereafter, Didcot developed as an important railway junction, with an impressive range of facilities, including marshalling sidings and a busy engine shed, as well as an important passenger station and a large, four-storey Provender Store in which fodder was stored for the company's horses. The Oxford branch joins the main line via a triangular junction, which is sited to the west of the platforms, while an avoiding line is provided for trains running between Paddington and Oxford that do not have to call at the station. *Left:* The original wooden station. *Below left:* The replacement buildings that were erected around 1885, after the earlier station had been destroyed by fire. *Below right:* An 'Achilles' class 4-2-2 locomotive at Didcot around 1912.

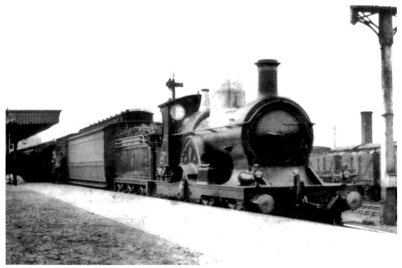

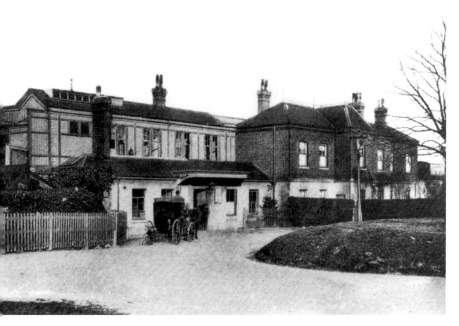

Didcot: The Main Station Buildings

The left-hand view, from an Edwardian postcard, shows the station forecourt during the early twentieth century, while the colour photograph was taken from a similar vantage point in July 2013. Didcot, which now generates approximately 2.5 million passenger journeys per annum, is a thriving rail centre and, as such, it has experienced little 'rationalisation' – the principal loss, in terms of infrastructure, being the Didcot, Newbury & Southampton (DN&SR) line. The DN&SR route was opened from Didcot to Newbury on 13 April 1882 and extended from Newbury to Winchester on 1 May 1885. Although it played a vital role during the Second World War, the line was never particularly busy, and it was closed on Saturday 5 March 1960.

Didcot: Platform Scenes

There were, at one time, seven platforms at Didcot, including two terminal bays on the south side of the station, but these were removed in 1965, leaving five lengthy through platforms in situ. These are now numbered in logical sequence from 1 to 5, Platforms 1 and 2 being the up and down main line platforms, while Nos 3 and 4 are the relief platforms and Platform 5 is an additional platform on the north side of the station. *Left:* A view looking eastwards along what is now Platform 5. *Below left:* This picture was taken around 1958 from what is now Platform 2. It shows 'City' class 4-4-0 No. 3440 *City of Truro* in one of the now lifted bay platforms – the veteran locomotive having been put to work on the erstwhile DN&SR line. *Below right:* A postcard view showing the station buildings around 1912.

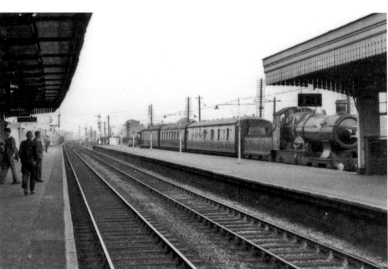

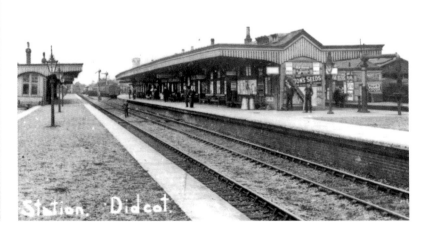

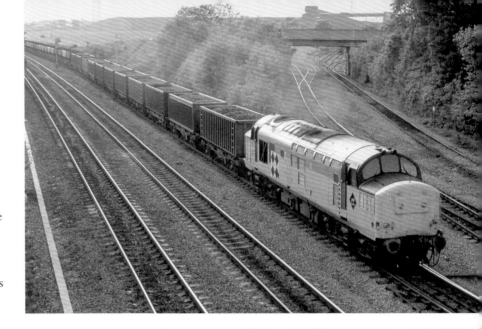

Didcot: Foxhall Junction and Didcot West Curve

Foxhall Junction (53 miles 56 chains), on the west side of the station, is a crossover point between the main and relief lines, and it also forms the western end of the Didcot triangle, which converges from Didcot North Junction at this point. The upper view shows class '37' locomotive No. 37213 at Foxhall Junction with an impressively long domestic coal train en route from East Usk Junction to West Drayton; the entrance to the Power Station branch can be seen to the right. The lower view shows class '58' locomotive No. 58043 on the west-to-north curve with an empty Didcot to Barrow Hill coal train on 2 May 1992.

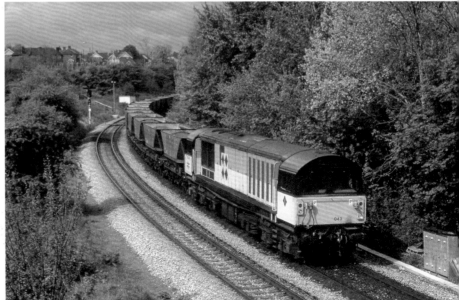

Right: Didcot: Foxhall Junction and the Power Station Branch
Vast stockpiles of Power Station coal dominate the background, as class '56' locomotive No. 56034 *Ogmore Castle* approaches Foxhall Junction with the 5.00 a.m. Robeston to Theale Murco oil train on 31 July 1986.

Left: Didcot: Foxhall Junction and the Power Station Branch
The unusual sight of a passenger train on the Power Station branch, as class '117' unit No. L402 leaves the fly ash loop after traversing the site with the Branch Line Society's 'Thames & Chiltern Rambler' railtour on 20 February 1993. This working had originated at Bishops Stortford, and it visited a number of other freight-only lines, including the Guinness branch at Park Royal and the UKF fertiliser depot at Akeman Street.

Didcot: South Moreton

These two photographs were taken at South Moreton, on the eastern approaches to Didcot. The upper view shows an HST set, headed by power car No. 43150, weaving its way from the up relief line to the up main line with the 11.01 a.m. Oxford to Paddington First Great Western service on 13 September 2012. The lower view shows class '50' locomotive No. 50026 *Indomitable* ambling along the up relief line on 12 September 1985 with a short test train, which includes the distinctive high-speed track recording coach No. DB999550. The test train is about to be overtaken by an empty parcels train, which is heading eastwards at much greater speed on the up main line behind class '31' locomotive No. 31117.

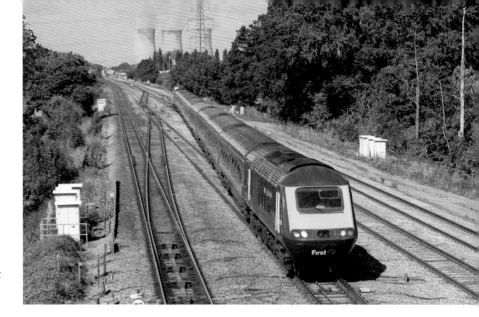

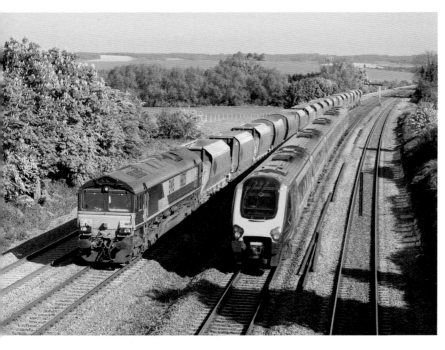

Right: Didcot: Steam Power
'Castle' class 4-6-0 No. 5029 _Nunney Castle_ passes Milton as it accelerates away from Didcot with the Paddington to Worcester 'Cotswold Venturer' railtour on 27 June 1993 – this was allegedly the first steam-hauled train to visit this section of line since the demise of Western Region steam on 31 December 1965.

Left: Didcot: Steam Power
A perfectly timed passing shot, taken at South Moreton on 27 April 2011, as class '66' locomotive No. 66135 heads westwards on the down relief line with an empty stone train, while the 12.19 a.m. Newcastle to Reading Crosscountry service speeds eastwards on the up main line.

Didcot: The Didcot Railway Centre

Didcot engine shed was closed in 1965 but, two years later, the site was taken over by the Great Western Society and transformed into the Didcot Railway Centre, one of Oxfordshire's leading tourist attractions. The upper view shows 'King' class 4-6-0 No. 6023 *King Edward II* on display at the Railway Centre on 5 May 2013, with steam rail motor No. 93 and auto-trailer No. 92 visible in the background. The locomotive is in the short-lived blue livery that was applied to the largest and most powerful express passenger locomotives after nationalisation. The lower view, taken on the same day, shows '57XX' class 0-6-0PT No. 3738 standing outside the main engine shed. This locomotive was built at Swindon in 1937, and it spent most of its working life in the London area. The engine is at present painted in wartime black livery.

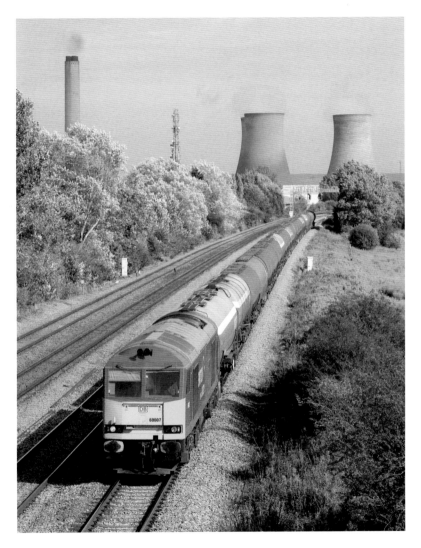

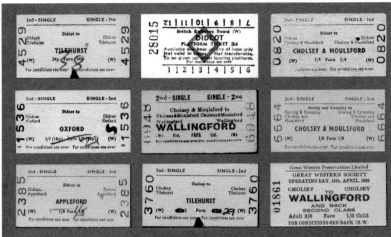

Didcot: South Milton

Above: A selection of tickets issued in the Didcot area, including a platform ticket, some BR second class singles, and a special ticket that was printed in connection with a special operating day on the Cholsey to Wallingford branch on 15 April 1968. *Left:* The final view of Didcot shows class '60' locomotive No. 60007 *The Spirit of Tom Kendell* ambling along the down relief line at Milton (55 miles 20 chains) with the 1.35 p.m. Theale to Robeston Murco oil empties. The wisp of smoke from Didcot Power Station's chimney indicates that the doomed coal-fired plant is using up some of its few remaining hours of generating time.

Steventon

Heading due west from Didcot, present-day trains speed past the remains of Steventon station (56 miles 42 chains), which was opened on 1 June 1840. The station was situated at the eastern extremity of the village, and it consisted of up and down platforms for passenger traffic, together with a small goods yard. Steventon was closed to passengers on Saturday 5 December 1964, but goods traffic was handled until March 1965. *Right:* The station in the 1960s, looking east towards Paddington. *Below right:* Class '66' locomotive No. 66621 passing Stocks Lane Level Crossing with the 11.56 a.m. Westbury to Stud Farm ballast empties on 29 September 2009. There are two level crossings here, both of which are sited to the west of the former station. *Below left:* A postcard view of Steventon station around 1912.

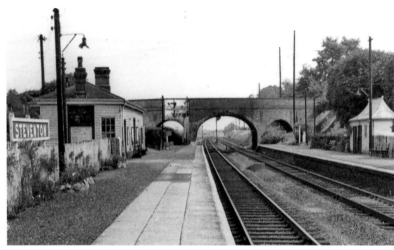

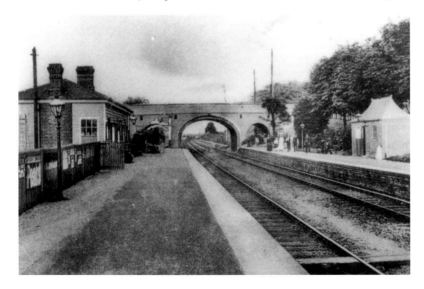

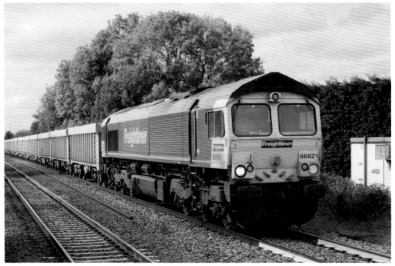

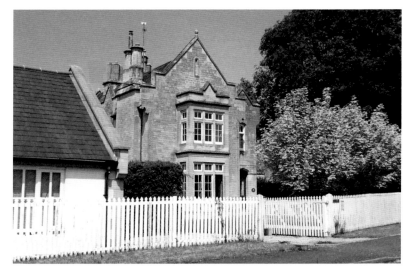

Steventon: The Brunel Houses

Left: The station building and platforms were demolished after closure, but two stone-built railway houses have nevertheless survived in the former station yard, and one of these is shown in the accompanying pictures. This substantial, Brunel-designed structure was built to accommodate the superintendent of the Line, and it was also used for GWR board meetings during the early days of the company. *Below left:* The Brunel house. *Below right:* Class '60' locomotive No. 60041 passes Steventon with the 1.30 p.m. Theale to Robeston Murco oil empties on 22 May 2007. Didcot Power Station can be seen in the distance.

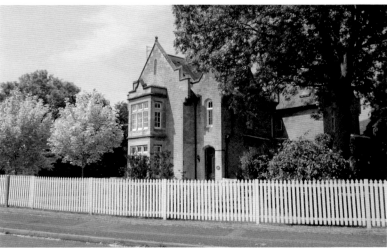

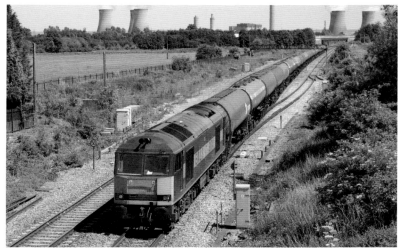

Wantage Road

Wantage Road, 60 miles 34 chains from Paddington, was opened in November 1846 to serve the nearby town of Wantage. It became a junction on 11 October 1875, when the Wantage Tramway was opened for passenger traffic. The station was rebuilt during the 1930s, when the GWR quadrupled the line between Wantage Road and Challow, necessitating the provision of a new up platform beside the up relief line. Wantage Road was closed on 5 December 1964 and the station was then demolished, although its site can still be discerned. *Right:* Looking east towards Paddington during the early 1960s. *Below right:* A colour view showing an HST set headed by power car No. 43002 passing the remains of the station with the 6.35 p.m. Paddington to Swindon service on 17 May 1992. *Below left:* A postcard view of Wantage Road station, looking east towards Paddington before the line was quadrupled.

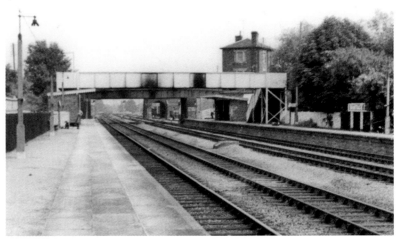

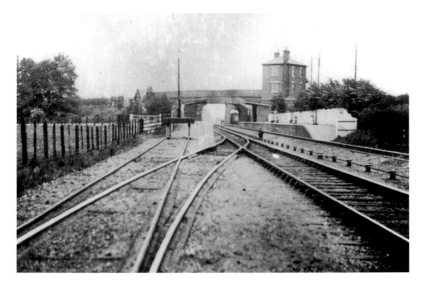

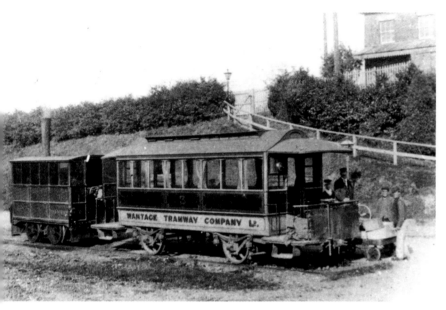

Wantage Road: The Wantage Tramway

The Wantage Tramway was opened for goods traffic on 1 October 1875 and for passengers on 11 October. The tramway commenced in Wantage Road goods yard and, for much of its length, this 2½-mile line was laid alongside the main A338 road. At Wantage, the tramway came to an end in a small terminus known as Wantage Town station, while a goods branch diverged from the tramway main line at Grove Road Crossing and terminated in a goods yard known as The Lower Yard. The Wantage Tramway lost its passenger services on 31 July 1925, but freight traffic was carried until December 1945. The left-hand view shows tram engine No. 4 and tramcar No. 3 at the WTC passenger terminus at Wantage Road, c. 1905. The photograph on the right, in contrast, shows class '66' locomotive No. 66415 pulling slowly away from Wantage Road loop with the 11.56 a.m. Westbury to Stud Farm ballast empties on 15 January 2013.

Right: Wantage Road

In superb lighting conditions, the dark, menacing clouds contrasting with autumnal foliage, an HST set headed by power car No. 43005 approaches the site of Wantage Road station with the 1.48 p.m. Paddington to Cheltenham First Great Western service on 17 November 2009.

Left: Wantage Road

Class '37' locomotives Nos 37894 and 37887 *Caerphilly Castle* wait in the up loop at Wantage Road on 15 April 1997 while working the 5.00 a.m. Cardiff Tidal to Purfleet steel train. Although part of the up platform was removed when the relief lines were reinstated during the early 1990s, the remains of the former down platform can still be seen on the extreme left of the picture.

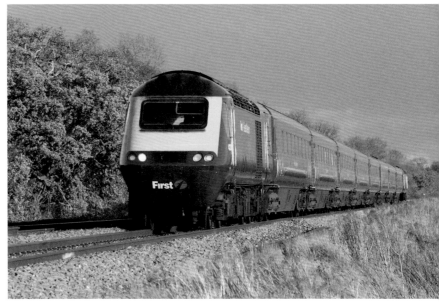

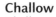

Challow

Challow (63 miles 30 chains), was opened as Faringdon Road on 20 July 1840, the name being changed in 1864. The station was extensively rebuilt as part of the widening operations carried out by the GWR in the 1930s. Challow was closed, along with the other stations between Didcot and Swindon, on Saturday 5 December 1964, but its site is still marked by goods loops. The black-and-white picture provides a glimpse of Challow station, looking west around 1963, while the colour photograph shows an HST set led by power car No. 43092 speeding past the site of the station with the 1.45 p.m. Paddington to Swansea First Great Western service on 12 May 2009.

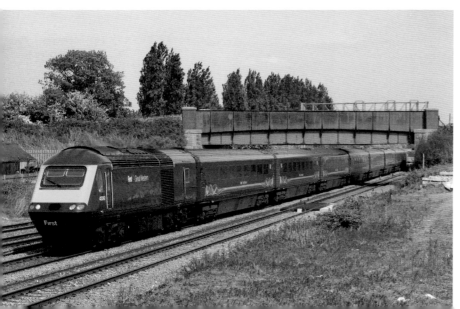

Right: Challow
This view of Challow station looking east was taken shortly before closure.

Left: Challow
Colas Rail class '66' freight locomotive No. 66850 *David Maidment OBE* passes Challow with the 7.55 a.m. Westbury to Bescot service on 2 January 2014. The train has just moved across onto the up relief line, where it will wait until the 9.00 a.m. Bristol Temple Meads to Paddington First Great Western HST overtakes it. The bridge that can be seen in the background will shortly be demolished in connection with the forthcoming Great Western electrification scheme.

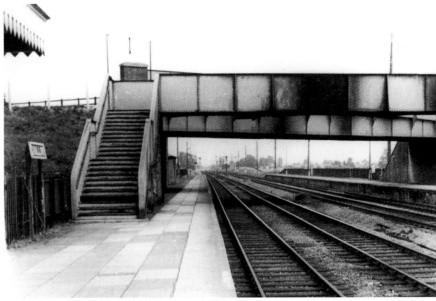

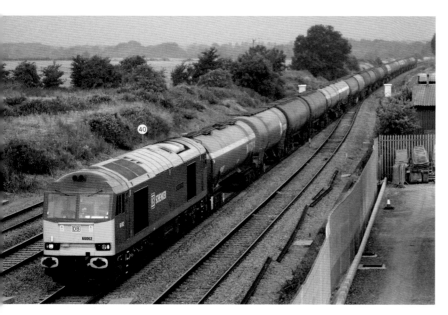

Right: Challow

The Royal Train, returning as an empty stock working from Haverfordwest to Euston, pulls into the up loop at Challow behind class '67' locomotive No. 67005 *Queen's Messenger* on 12 May 2009; sister engine No. 67006 *Royal Sovereign* is coupled to the rear of the train.

Left: Challow

On 16 July 2013, the 10.49 p.m. Robeston to Theale empty oil train ran via Swindon and Didcot because of engineering work on the Berks & Hants route. The diverted train is seen passing the site of Challow station on the up main line at 5.42 a.m. on the following morning, the locomotive being DB Schenker class '60' No. 60062 *Stainless Pioneer*.

Uffington Junction

Uffington, the next stop (66 miles 43 chains), was opened on 1 June 1864, in connection with the Faringdon branch, which diverged northwards on the up side. Up and down platforms were provided here, the up platform being an island with tracks on either side, as shown in the upper picture. Faringdon trains used the eastern extremity of this third platform, but the platform line was not signalled for through working, and the western end was used as a siding. The Faringdon branch was closed to passengers on 29 December 1951, and to goods in July 1963, while Uffington station was closed on 5 December 1964. The recent colour photograph shows Freightliner class '66' locomotive No. 66535 passing Uffington with the 9:58 a.m. Wentloog to Southampton freightliner service on 29 September 2011. The photograph was taken from a little-used public footpath that crosses the line near the site of the abandoned station.

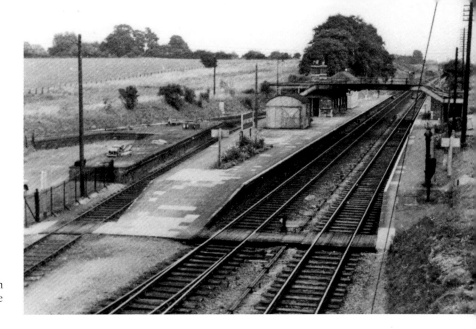

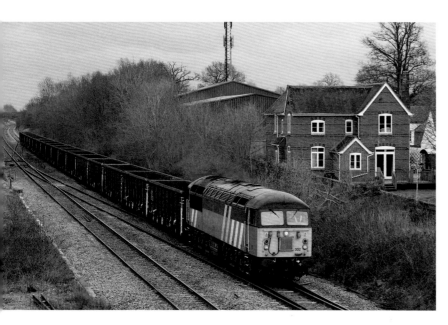

Right: Uffington Junction

'Hall' class 4-6-0 No. 4965 *Rood Ashton Hall* and sister engine No. 4953 *Earl of Mount Edgcumbe* pass Baulking, to the west of Uffington, with the Vintage Trains 'Coronation Express' railtour from Didcot to Tyseley on 2 April 2011.

Left: Uffington Junction

Class '56' locomotive No. 56302 passes Uffington station on 27 February 2012 with the 12.04 p.m. Wembley to Cardiff Canton scrap empties. The overgrown area to the left marks the site of the up platform.

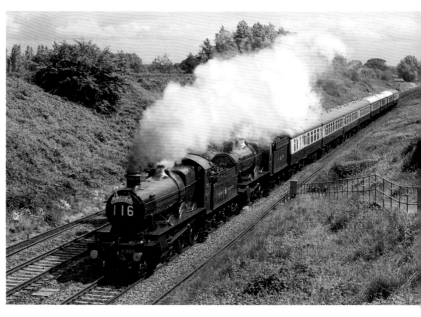

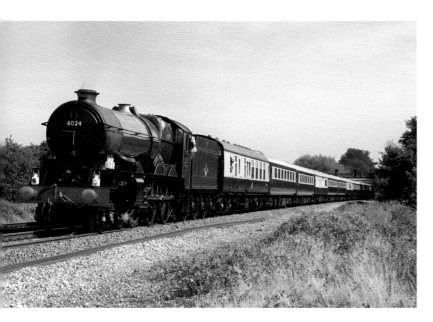

Right: Uffington Junction

Winter sunlight shines weakly upon an eastbound HST unit led by power car No. 43183, as it heads eastwards across the Vale of White Horse near Uffington with the 6.00 a.m. Haverfordwest to Paddington Inter City service on 10 December 1986.

Left: Uffington Junction

'King' Class 4-6-0 No. 6024 *King Edward I* passes Uffington with the 10.11 a.m. Paddington to Bristol Temple Meads special on 9 September 2006. This excursion was run to celebrate the centenary of Poet Laureate Sir John Betjeman's birth, and it conveyed distinguished guests to a grand celebration at St Mary Redcliffe church. The train had just been held in Challow loop for an hour's watering stop.

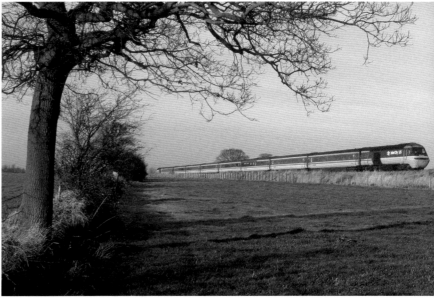

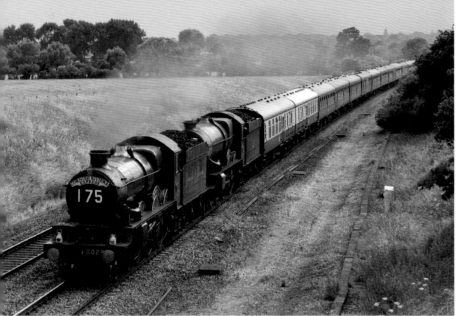

Shrivenham

Shrivenham, 71 miles 42 chains miles from Paddington, was opened on 17 December 1840 and closed as part of the purge of wayside stations between Didcot and Swindon that took place on 5 December 1964. The upper photograph, taken at Compton Beauchamp between Uffington and Steventon on 28 June 2010, shows 'Castle' class 4-6-0 No. 5029 *Nunney Castle* and 'King' class 4-6-0 No. 6024 *King Edward I* making light work of a railtour from Penzance to Paddington, which had started its journey as the 9.07 a.m. from Penzance to Bristol. The lower view shows an HST set headed by power car No. 43035 speeding past the overgrown platforms at Shrivenham with the 7.58 a.m. Swansea to Paddington First Great Western service on 27 June 2011.

Right: **Shrivenham**
Class '67' locomotive No. 67002 *Special Delivery* speeds past the abandoned station with the 10.00 a.m. Frome to Preston 'Raileasy' working on 27 July 2011, while the 10.00 a.m. Paddington to Paignton HST Torbay Express service rushes past on the up main line. The train from Frome was carrying happy festival-goers back from the Glastonbury Festival, where they had seen such big-name acts as U2, B. B. King, Don McLean, Morrissey, Paul Simon, and of course the undoubted highlight of the event – the Wombles!

Left: **Shrivenham**
Class '60' locomotive No. 60049 passes Shrivenham on 30 November 2013 while hauling the 11.27 a.m. Theale to Margam empty oil tank train.

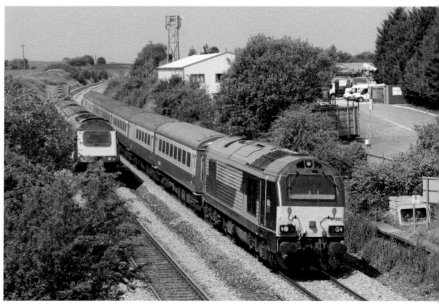

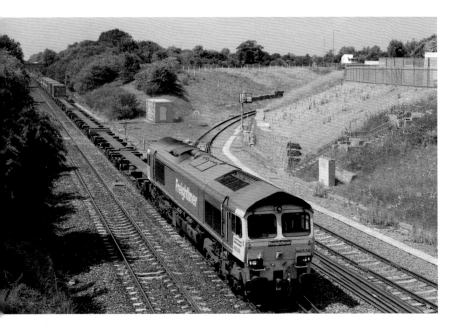

Right: **Swindon: The Eastern Approaches**
Maintaining their westerly heading, down trains speed past the village of
Bourton and, crossing the busy A420 road on the skew-arched Acorn Bridge,
they then reach a long embankment that carries the railway towards the
outskirts of Swindon. On 20 November 1933, the GWR opened a halt at
Stratton Park (75 miles 5 chains) to serve the inhabitants of South Marston
and the nearby village of Stratton St Margaret. The halt was closed on
5 December 1964.

Left: **Swindon: The Eastern Approaches**
Freightliner class '66' locomotive No. 66536 passes South Marston on
22 June 2010 with the 10.00 a.m. Bristol Parsons Street to Tilbury
Freightliner service. The line curving away to the right serves the Swindon
Keypoint industrial estate, and is used regularly by trains from the Honda
car plant.

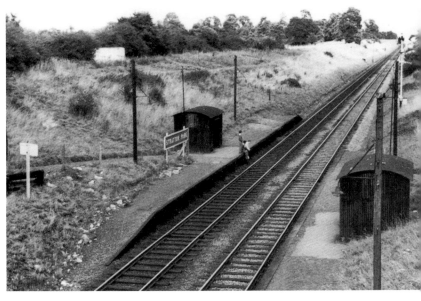

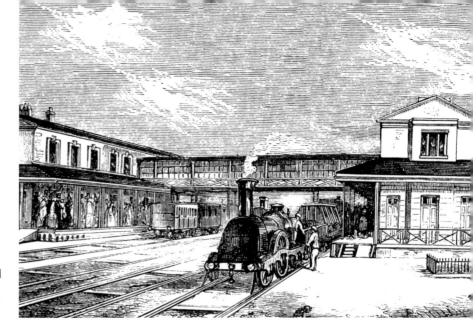

Swindon

Opened on 31 May 1841, Swindon station (77 miles 23 chains) was a junction from its very inception – the first section of the Cheltenham & Great Western Union Railway having been opened as far as Kemble on that same day (although GWR trains did not reach Cheltenham until 1847). Swindon was also the site of the Great Western's principal locomotive, carriage and wagon works – the Works being sited to the west of the passenger station in the 'V' of the junction between the Bristol and Cheltenham lines. The upper drawing provides an impression of the station as it appeared around 1850, while the lower photograph dates from around 1962.

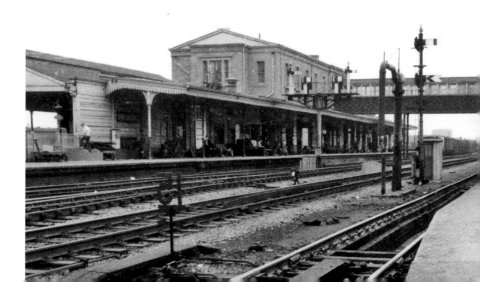

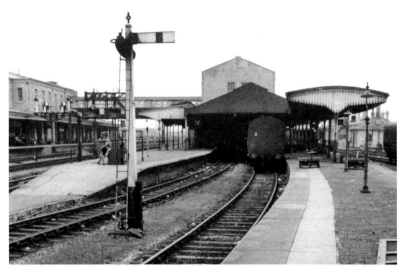

Swindon: Platform Scenes

Prior to nationalisation, Swindon passenger station had featured two very wide island platforms, with bays at each end – some of these being used as carriage sidings. In steam days the platforms were numbered from 1 to 8, Nos 1, 4, 5 and 8 being the through platforms, while Nos 2, 3, 7 and 8 were the four terminal bays. The southern island was subsequently taken out of use, and the remaining platforms on the north side were then designated platforms 1, 2 and 3. However, traffic has increased to such an extent in recent years that a platform has been reinstated on the down side, and this has become Platform 4. *Left and below left:* These two photographs, both from around 1963, show terminal bays 2 and 3 at the Bristol end of the southernmost island platform *(left)*, and the former Platform 8, on the north side of the station, which is regarded as Platform 1 under the current platform numbering system *(below left)*. *Below right:* A general view of Swindon station during the 1960s.

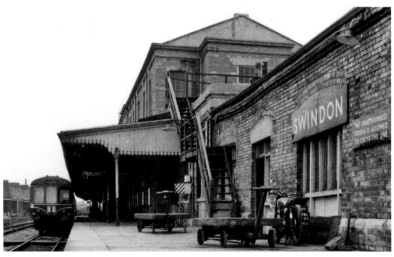

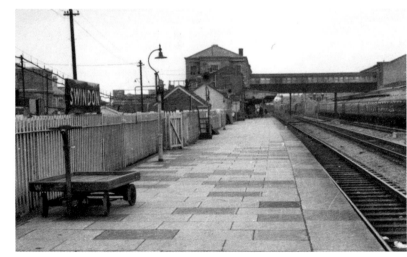

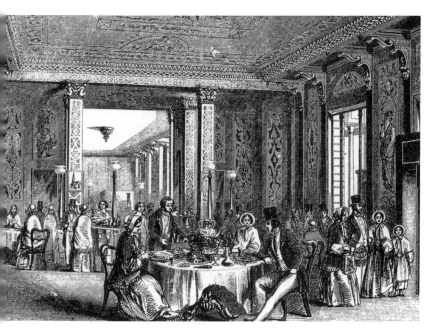

Swindon: The Refreshment Rooms

Until the introduction of corridor trains and onboard toilet facilities, it had been customary for long-distance trains to stop for refreshments at selected stations, and in this context it was decided that all regular trains would stop at Swindon 'for a reasonable period of about ten minutes'. To facilitate this mode of operation, two large station buildings were provided on both platforms, each of which contained lavishly appointed refreshment rooms, staffed by 'pretty and obliging Hebes', who presided over 'the elegant and well-provided counters'. The basements contained kitchens, 'amply-fitted with culinary apparatus', while the upper floors provided hotel accommodation with sitting rooms on one side and sleeping accommodation on the other – the two buildings being linked by a 'covered gallery' or footbridge. The left-hand picture shows the interior of one of the first class refreshment rooms as they would have appeared around 1850, while the old postcard view shows the twin station buildings in around 1912.

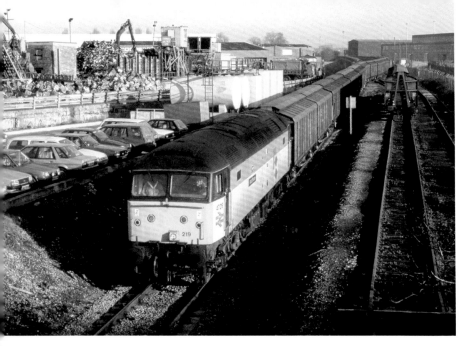

Swindon: Activity at Highworth Junction

Highworth Junction (76 miles 26 chains), to the east of the passenger station, was the junction for the Highworth line – a very rural branch that was opened on 9 May 1883 and closed to passengers in 1953. However, the line remained open for freight traffic for several years, and the southern extremity of the branch has remained in use for private siding traffic, as exemplified by the upper picture, which shows class '47' locomotive No. 47219 *Arnold Kunzler* pulling its lengthy train out of the Rover car plant on 16 February 1993. The sidings on the right have now been removed, while the Swindon car plant, which can be seen in the background, now produces car body panels for the BMW Mini. The lower photograph shows class '08' diesel shunter No. 08589 propelling a rake of Engineering Department vehicles into the down sidings at Highworth Junction on 26 October 1992.

Swindon: The GWR Works

On 25 February 1841, the Great Western directors authorised the construction on 'an engine establishment at Swindon commensurate with the wants of the company'. This decision had momentous consequences for Swindon, which was transformed from a Wiltshire market town to an engineering centre of world-class importance. The works was opened on a 'green field' site on Monday 2 January 1843 and, in the words of the *Little Guide to Wiltshire*, the new Works 'were quickly surrounded by a town that came to be known as New Swindon, or Swindon New Town, a mushroom growth that suddenly covered fields and quagmires, looked down upon by the venerable old market town'. By 1912, Swindon was the most modern locomotive works in the country, while by the 1930s the Works covered over 300 acres – seventy-seven of which were fully roofed. The illustrations on this page show steam railmotor cars Nos 62 and 88 within the Works during the early years of the twentieth century.

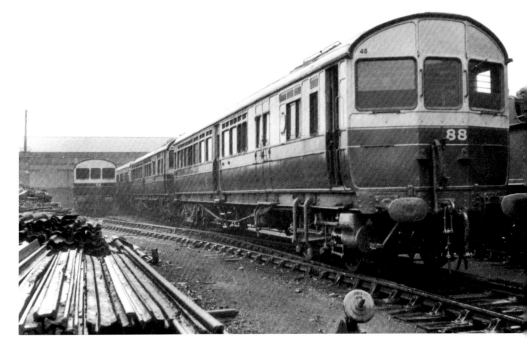

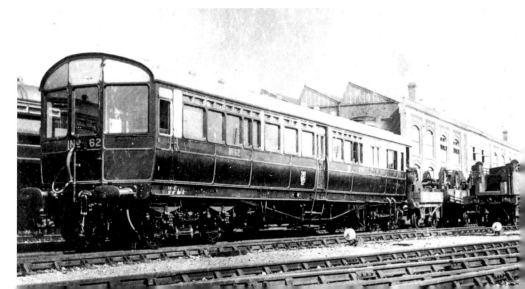

Swindon: The GWR Works

At its peak, Swindon Works was able to build locomotives at the rate of two per week, together with about 250 passenger vehicles. By the early 1930s, approximately 1,000 locomotives, 5,000 coaches and 8,000 goods wagons were being repaired per annum, while a great variety of general work was also carried out, including castings and forgings for other departments of the GWR. The upper view, from a commercial postcard of around 1910, shows newly cast cylinder blocks in the Iron Foundry, while the lower view shows the interior of the Erecting Shop. The diminutive locomotive visible to the left is Wantage Tramway engine No. 5 *Shannon* (known locally as *Jane)*. By the 1920s, as many as 14,000 people were employed by the GWR in Swindon, which could claim, by any definition, to be an archetypal 'railway town'.

Right: Swindon: A Plan of the Works

A plan of the Works in the late 1960s. The Erecting Shop is on the extreme left, while the wagon shop is in the centre of the site and the carriage repair shop is on the right.

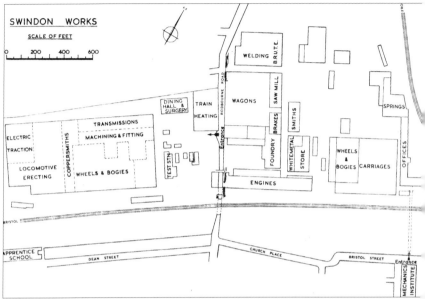

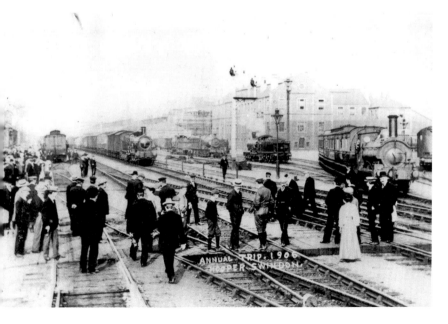

Left: Swindon: The Swindon Trips

The annual 'Swindon Trips' were a local institution, analogous, in many ways, to the 'Wakes Week' holidays that took place in northern industrial towns. It was customary for the GWR to provide free transport for the workers and their families during the 'Trip Week' in July, and thousands of people would be conveyed from Swindon in special trains to holiday destinations such as Weymouth, St Ives and Weston-super-Mare. This 1906 postcard scene shows trippers waiting for their trains, many of which started from within the confines of the Works.

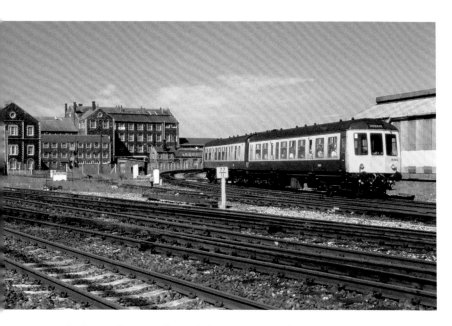
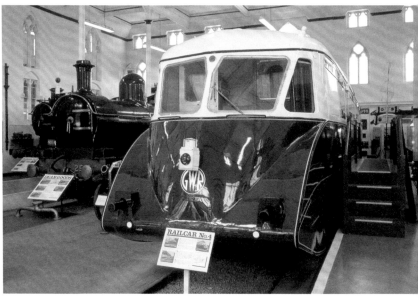

Swindon: The Demise of the GWR Works

In 1985, it was announced that Swindon Works would be closed in its entirety with the loss of 2,500 jobs as part of a 'restructuring' operation carried out by British Rail Engineering Ltd. The closure was duly carried out in January 1986, and much of the site was subsequently redeveloped as a retail sales outlet known as The Swindon Designer Village. The left-hand view shows class '108' unit No. B969 rounding the sharp curve into Swindon station with the 9.35 a.m. Gloucester to Swindon service on 15 July 1989. The recently closed Swindon Works can be seen in the background – this part of the site has now been taken over by English Heritage. The GWR Museum at Swindon was ceremonially opened on 22 June 1962, its original home being a building known as 'The Barracks' that had been built as a railwaymen's hostel, but later became a Methodist chapel. However, following the closure of the Works, the museum was relocated to a new home within the Works complex. The view to the right shows the interior of the original museum during the 1980s.

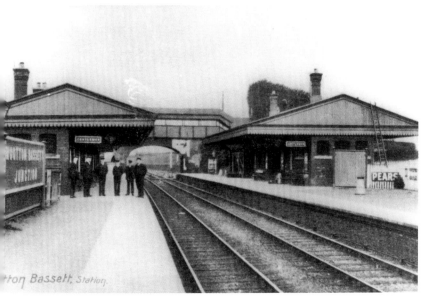

Right: Wootton Bassett
A First Great Western HST set headed by power car No. 43158 speeds past the station site with the 9.28 a.m. Swansea to Paddington service on 18 July 2013.

Left: Wootton Bassett
Having left Swindon, down trains reach the site of Wootton Bassett station (82 miles 70 chains), which was opened on 30 July 1841. The station became a junction in 1903, when the Badminton Cut-Off was opened to provide a shortcut for South Wales services that had hitherto travelled via Bristol. A glimpse of the station around 1912 is shown here, looking east towards Paddington; the buildings here were of standard Great Western design. Wootton Bassett was closed to passengers with effect from Monday 4 January 1965, while goods facilities were withdrawn in the following October (apart from private siding traffic).

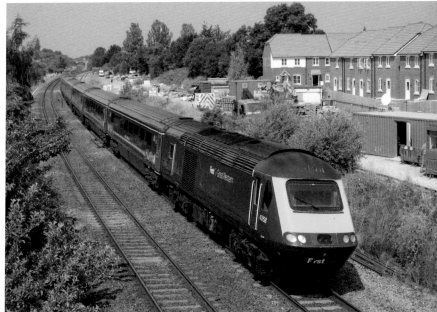

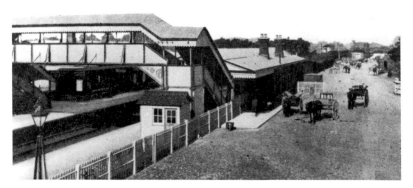

Wootton Bassett

Left: A further view of the standard Great Western station buildings and footbridge at Wootton Bassett, looking west towards Bristol in the early years of the twentieth century. *Below left:* Freightliner class '66' locomotive No. 66607 passes the site of Wootton Bassett station with the 11.56 a.m. Westbury to Stud Farm ballast empties on 18 July 2013. The train had been held for a few minutes just beyond the bridge in the background, so that a South Wales HST could cross in front of it. *Below right:* The western end of Wootton Basset station, with the goods yard visible to the right.

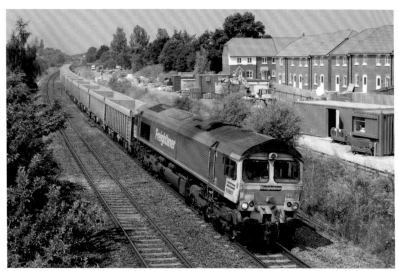

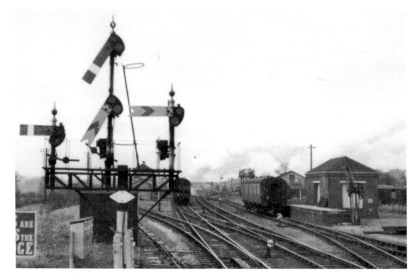

Dauntsey

From Wootton Bassett, trains descend west-south-westwards on a falling gradient of 1 in 100 to Dauntsey, some 4¾ miles further on. This small station was opened on 1 February 1868, and it served as the junction for branch services to Malmesbury from 1877 until 1933, when the southern section of the Malmesbury line was closed as part of a rationalisation scheme. *Right:* Looking west towards Bristol during the early years of the twentieth century. The Malmesbury branch bay is visible beyond the road overbridge. *Below right:* A general view of Dauntsey station during the 1960s. *Below left:* A view eastwards along the up platform, with the main station building visible to the left. Dauntsey was closed with effect from Monday 4 January 1965.

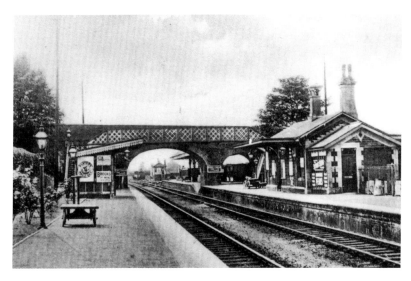

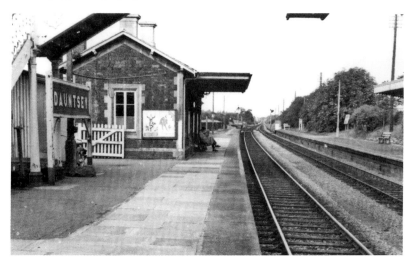

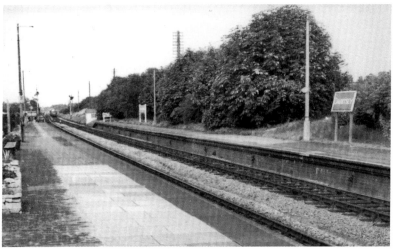

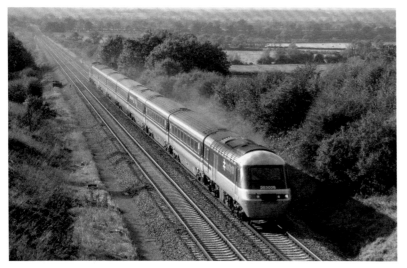

Dauntsey

Left: An HST set headed by power car No. 43125 passes Tockenham Wick, near Dauntsey, with the 12.58 p.m. Weston-super-Mare to Paddington service on 29 October 1983. The unit, still carrying the soon-to-be abandoned set numbers, was one of the first recipients of 'executive livery'. At that time there were only two complete new-liveried HST sets, and No. 43125 had been one of the first power cars released in the new colours. *Below left*: A general view of the station during the 1960s. *Below right*: Class '59' locomotive No. 59001 *Yeoman Endeavour* passes Dauntsey on 16 March 2000 while working an empty stone train from Wootton Bassett to Merehead.

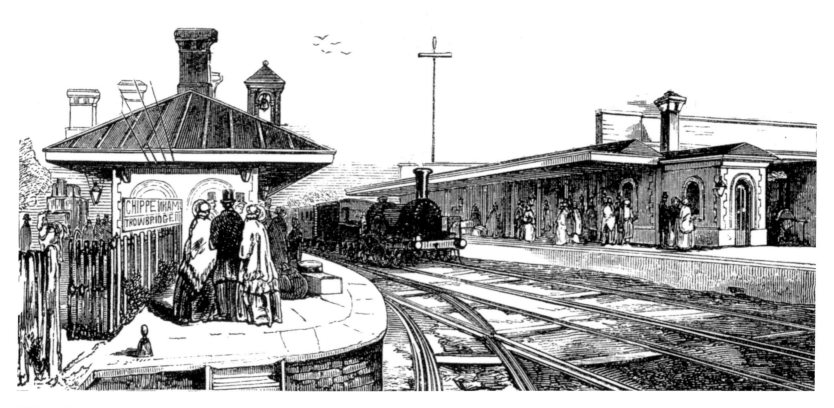

Chippenham

From Dauntsey, the route heads south-westwards to Chippenham (93 miles 76 chains) passing, en route, the site of Christian Malford Halt – an unstaffed stopping place that was opened on 18 October 1926 and closed in January 1965. This contemporary drawing provides a glimpse of Chippenham station as it appeared in broad gauge days, around 1850. This station was opened on 31 May 1841, and it served as the junction for branch services to Calne from 3 November 1863 until the demise of the Calne line on Saturday 18 September 1965.

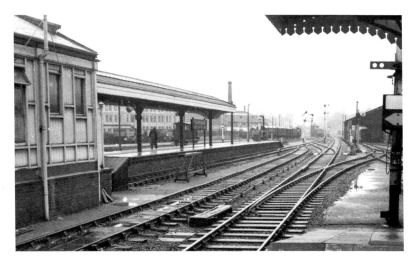

Chippenham

Left: A view from the 1960s of Chippenham station, looking east towards Paddington. The Calne branch bay can be seen in the centre of the picture, while the goods shed is on the extreme right. The large factory that can be glimpsed in the background is the Westinghouse Signalling Works. *Below left:* The western end of Chippenham station, looking towards Bristol during the 1960s. *Below right:* The Bristol end of the station, looking east. There are two footbridges, one of which links the up and down sides of the station, while the other carries a public footpath across the line. Chippenham now has just two platform faces on either side of the northernmost platform. The former down platform on the south side has had its track removed, although the Brunel-era station buildings remain intact.

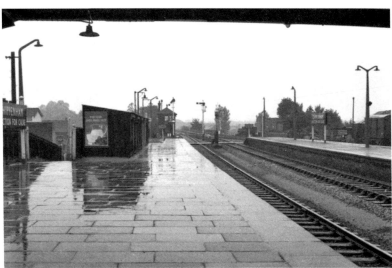

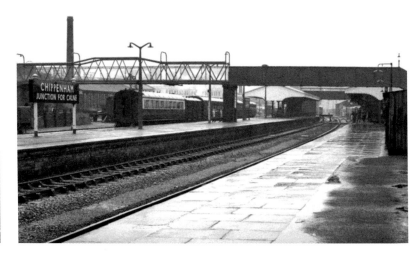

Corsham and Box Tunnel

As trains leave Chippenham, they head southwards along a lofty embankment, after which the railway curves onto a westerly alignment as it passes the abandoned station at Corsham (98 miles 26 chains). This station was opened on 30 June 1841 and closed in January 1965. Beyond, the line enters Box Tunnel, 3,212 yards in length, and one of the greatest engineering achievements on the Great Western system. Cut partly through great oolite and partly through an admixture of clay, blue marl and inferior oolite, the tunnel was completed in June 1841 after 5¼ years' work. At one stage, a ton of gunpowder and a ton of candles were being consumed every week. The upper view shows class '37' locomotive No. 37705 at Corsham, at the east end of the tunnel, with the 11.21 a.m. Calvert to Bristol 'Binliner' empies on 20 April 1995, while the lower view shows Box Mill Lane Halt, to the west of the tunnel. This unstaffed stopping place was opened on 31 March 1930 and closed in January 1965.

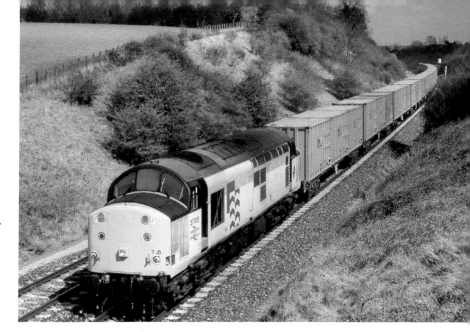

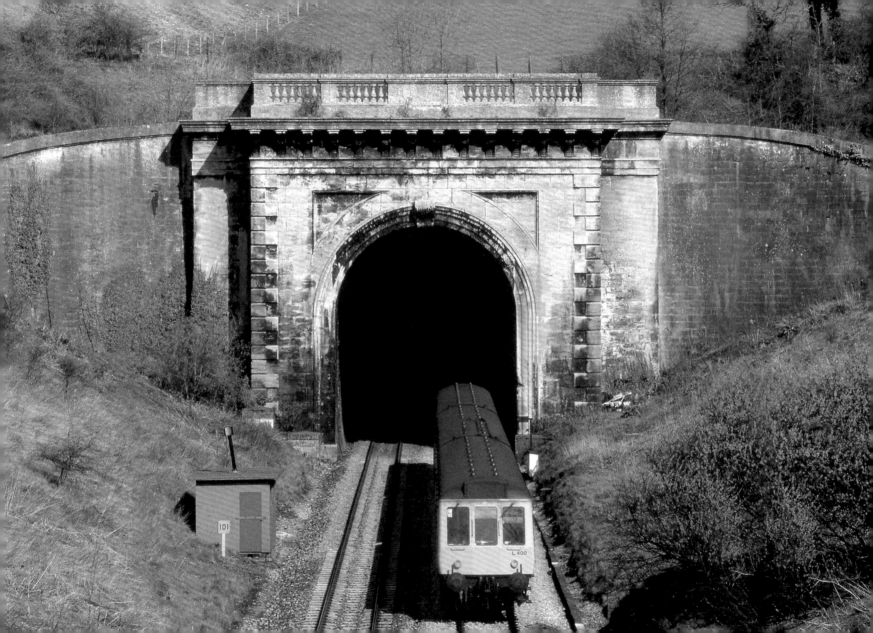

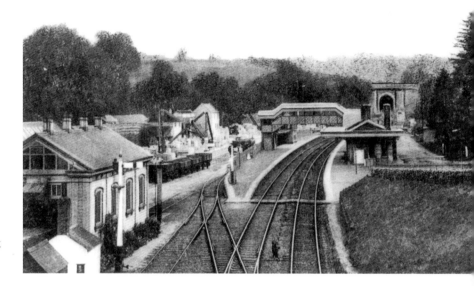

Right: Box Station

Box station, 101 miles 69 chains from Paddington, was sited a short distance beyond Box Middle Hill Tunnel. It was opened on 4 June 1841 and closed in January 1965. The upper picture is a postcard view of the station from around 1910, looking east towards Paddington. The main station building is on the down side, and the goods yard is sited to the rear of the up platform. Stone traffic was particularly important here and at neighbouring Corsham. The lower view shows Box station during the 1960s, looking west towards Bristol. The signal box and plate girder footbridge were both standard Great Western structures.

Opposite: Box Tunnel: The Western Portal

Having emerged from Box Tunnel, westbound trains then pass through Box Middle Hill Tunnel, which is much shorter, with a length of just 200 yards. This photograph depicts the western portal of Box Tunnel: the colour view shows a class '117' three-car unit emerging from the tunnel mouth in April 1982. The tunnel is dead-straight, and on a gradient of 1 in 100, falling towards Bath. There is a persistent legend that, on a certain day each year, the sun shines through the tunnel as it rises over Box Hill. This phenomenon was supposed to take place on 9 April, which was Brunel's birthday, although investigations carried out in 1988 revealed that direct illumination takes place on 6 and 7 April.

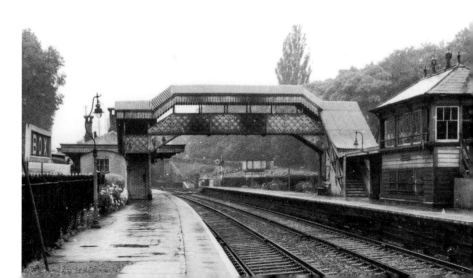

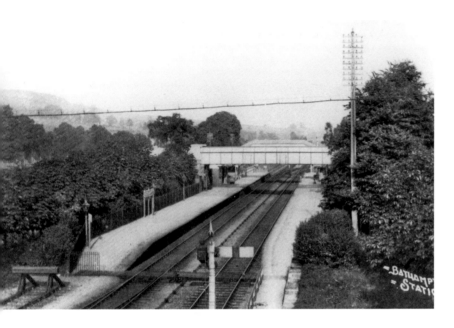
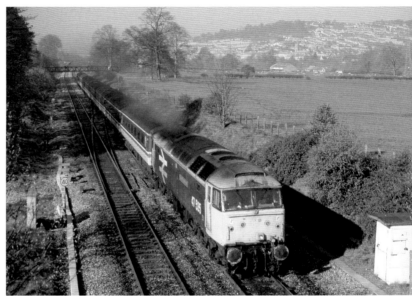

Above: **Bathampton**

Passing the site of a closed halt at Bathford, trains head south-westwards to Bathampton Junction (104 miles 45 chains), where the Weymouth route converges with the Bristol main line. The left-hand view shows Bathampton station, which was opened on 2 February 1857 and closed on Saturday 1 October 1966. There was a small goods yard here, together with a private siding that served J. T. Holmes & Co.'s timber mill. The colour photograph shows class '47' locomotive No. 47535 *University of Leicester* passing Bathampton with the 9.03 a.m. Bristol Temple Meads to Paddington Inter City service on 5 April 1990. This scene has now been transformed by the rerouted A4 trunk road, which runs parallel to the railway at this point.

Opposite: **Bathampton**

Running ten minutes early, the 6.45 a.m. Swansea to Reading empty newspaper train passes Bathampton Junction behind class '47' locomotive No. 47482. This engine was withdrawn in 1993 and cut up shortly afterwards. The Weymouth line was built by the Wilts, Somerset & Weymouth Railway (WS&WR), which was opened between Thingley Junction, near Chippenham, and Westbury on 5 September 1848, although the line did not reach Weymouth until 20 January 1857. The Bathampton to Bradford Junction section was opened a month later, on 1 February 1857.

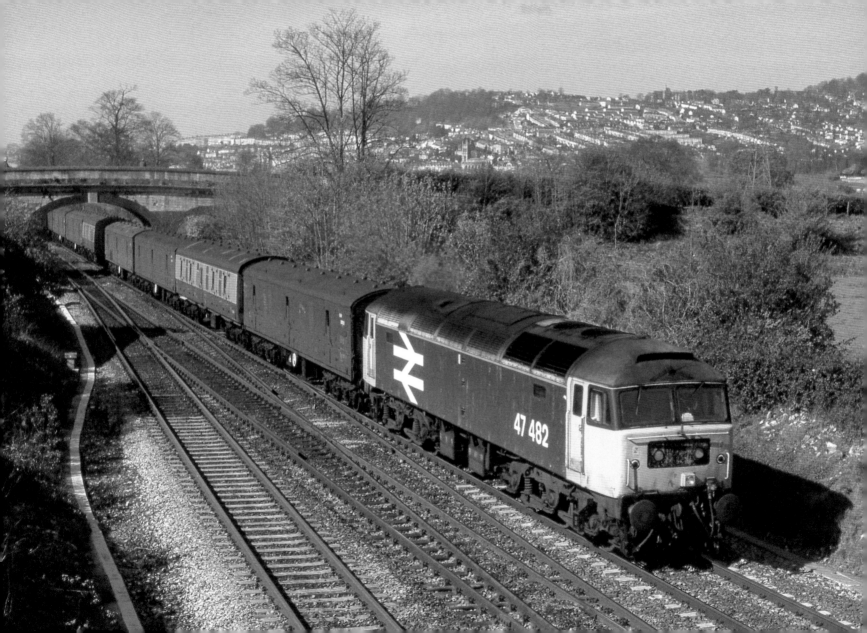

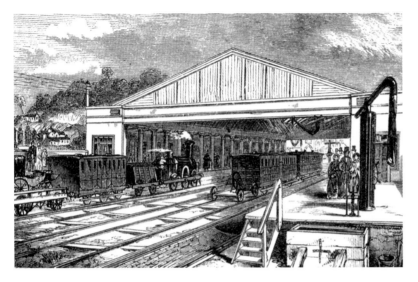

Bath Spa

From Bathampton, the line continues towards Bath, with the Kennet & Avon Canal running parallel to the left. Entering the urban area, the railway curves onto a southerly heading, before turning south-westwards for the final approach to Bath Spa station (106 miles 71 chains). Opened on 31 August 1840, the station is situated on a viaduct, and it boasts two curved platforms. There were formerly four lines between the platforms, but the centre lines have now been lifted, leaving an unusually wide gap between the up and down platforms. This contemporary print reveals that, in the 1840s, the station had an overall roof, but this feature was removed in 1897, when the present platform canopies were erected on both sides. The two lower views are looking westward along the down platform during the 1960s; the two platforms are linked by an underline subway. The west end of the platforms are shown in the photograph below left, looking west towards Bristol around 1964.

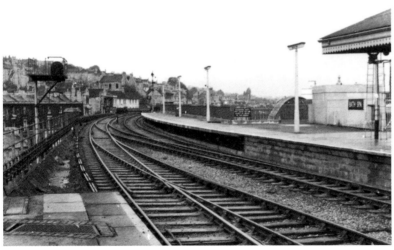

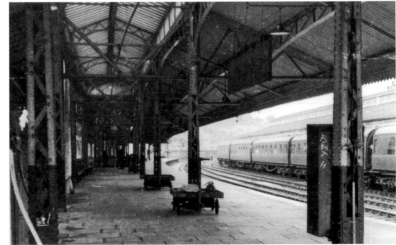

Bath Spa: The Brunelian Station Buildings

The station buildings are split-level structures, incorporating internal stairways that give access to the platforms. The up side building, pictured above, is graced by three Jacobean gables and a projecting oriel window, the overall effect being reminiscent of the English Renaissance style. The ground floor has eight arched openings that were originally part of an open arcade. The down side station building, in contrast, is of more austere appearance, as shown in the lower photograph. Both of these structures are of Brunel design, and they are now Grade II listed buildings.

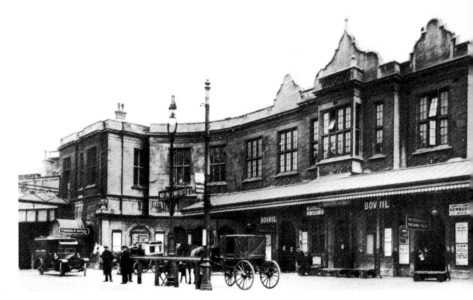

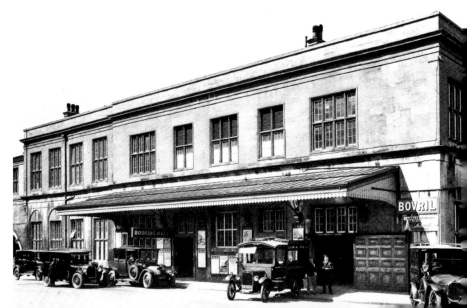

Oldfield Park and Saltford

Leaving Bath station, the line crosses the River Avon on a skew bridge and then runs westwards through the historic city on a lengthy viaduct, with the Avon visible to the right. The still-extant station at Oldfield Park, opened on 18 February 1929 (107 miles 72 chains), is the site of the Avon County Council refuse terminal, and the upper view shows class '56' locomotive No. 56051 waiting to leave the refuse sidings with a Calvert to Bristol Binliner service, while class '37' No. 37705 passes on the main line with an oil tank train on 30 October 1992.

After Oldfield Park, down trains rush past the closed stopping places at Twerton and Saltford – Twerton having been deleted from the railway network as long ago as 1917. The lower view shows Saltford, a wayside station sited 4¼ miles to the west of Bath, which was opened on 16 December 1840 and closed on 3 January 1970. There were, at one time, three tunnels on this section, but two of these were opened out and replaced by cuttings during the 1890s.

Keynsham & Somerdale

Keynsham (113 miles 63 chains), was opened on 31 August 1840 and, as shown in the picture to the right, it is a somewhat more important station than Saltford, its impressive, stone-built station buildings being similar in style to the Brunelian buildings at Steventon. Like a large number of less important stations on the national network, Keynsham has lost most of its Victorian infrastructure, although the replacement station building is better than the usual 'bus shelter' type structure. The photograph below right, taken on 30 October 1992, shows class '158' unit No. 158869 passing through the station with the 9.20 a.m. Swansea to Portsmouth Harbour Regional Railways working, while a handful of travellers wait for the following 11.31 a.m. Bristol to Weymouth service. *Below left:* Keynsham & Somerdale station, framed by the footbridge during the early 1900s.

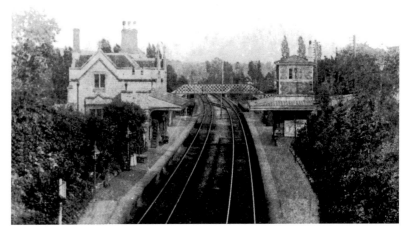

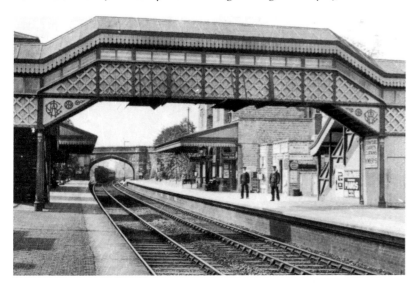

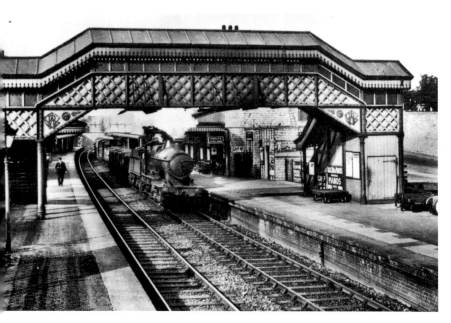

Right: Keynsham & Somerdale

Class '33' locomotive No. 33048 passes Keynsham with the 1.10 p.m. Portsmouth Harbour to Bristol Temple Meads service on 14 May 1988, the last day of class '33' operation on the route.

Left: **Keynsham & Somerdale**

A postcard view of Keynsham & Somerdale, looking west towards Bristol around 1912 as a 4-4-0 locomotive runs through the station with an up freight train. The 1938 Railway Clearing House *Handbook of Stations* shows three private sidings at Keynsham, one of which served Keynsham Paper Mills, while the others served Messrs E. S. & A. Robinson and Fry's Somerdale Chocolate Factory (later Cadbury's). The chocolate factory made headline news in 2007 when Cadbury's announced that production would be moved to Poland, and despite efforts to save the factory it was closed in 2011.

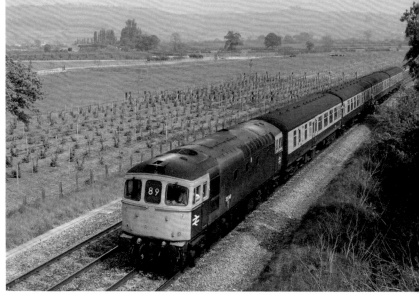

Bristol Temple Meads: The Eastern Approaches

The eastern approaches to Bristol are heavily engineered, and as trains approach Temple Meads they run through the 1,017-yard Fox's Wood Tunnel, which is followed by a much shorter 154-yard tunnel. St Annes Park (116 miles 58 chains) was sited just beyond the second tunnel; this station, shown to the right, was opened on 23 May 1898 and closed on 3 January 1970. The lower left view shows the eastern end of the station, looking towards Paddington during the 1960s.

Passing through a deep cutting that had been a tunnel until it was opened out in 1889, trains cross the Feeder Canal, which links the River Avon with Bristol Harbour and was once a busy commercial waterway. The colour photograph shows the 2.15 p.m. Paddington to Bristol HST working headed by power car No. 43015 crossing the canal bridge as it approaches Temple Meads station (118 miles 31 chains) on 10 April 1997. The unit is headed by power car No. 43015.

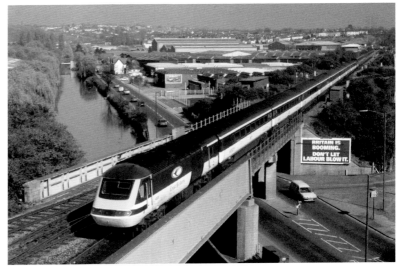

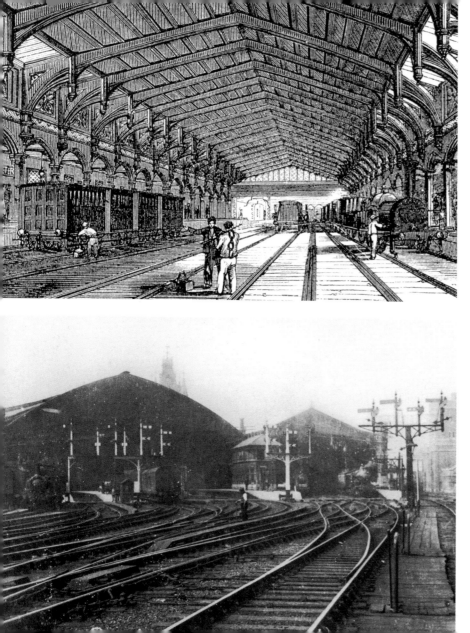

Bristol Temple Meads: The Old & New Train Sheds

The upper picture shows the interior of Brunel's original terminus, which incorporated a large train shed with a medieval-style hammer beam roof spanning fine parallel broad gauge tracks, together with a range of elaborate, late Gothic-style buildings that contained a boardroom and extensive office accommodation. The original terminus was aligned from east to west, and when the Bristol & Exeter Railway (B&ER) was opened in 1841, its station was laid-out on a north–south axis, necessitating a sharply curved connecting line between the two systems. This situation was far from ideal, and in 1865 the GWR, B&ER and Midland companies obtained Parliamentary consent for a new 'joint station'. When opened in the 1870s, this consisted of the original Brunelian terminus, together with new through platforms that diverged south-westwards on a curving alignment, and were covered by a spacious, Gothic-style train shed. The lower view, looking south-westwards in around 1912, shows the old and new parts of the station, the Brunel terminus being to the right, while the 1870s train shed can be seen to the left.

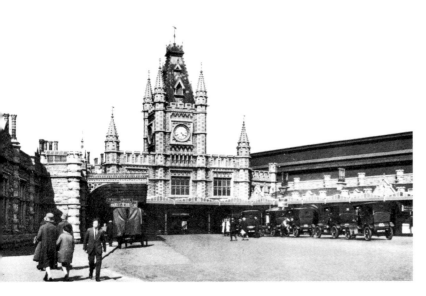

Left: Bristol Temple Meads: The Main Station Building

The roughly triangular space between the 1840s and 1870s stations is filled by a complex range of stone-built, late medieval-style buildings, as shown in this 1920s view. This attractive building is still in use, although the pyramidal roof on top of the clock tower was destroyed during the Bristol 'Blitz'. In addition to these Victorian buildings, Temple Meads acquired two additional island platforms, which were added on the eastern side of the station as part of a major improvement scheme that took place in the late 1920s and early 1930s, when the station was enlarged to cover about three times its previous area.

Right: Bristol Temple Meads: The Main Station Building

This busy 1930s scene shows the east end of the 1870s train shed, with 'Castle' class 4-6-0 No. 5069 *Isambard Kingdom Brunel* at the head of an up express, and 'Bulldog' class 4-4-0 No. 3378 departing with a train of Southern Railway coaches.

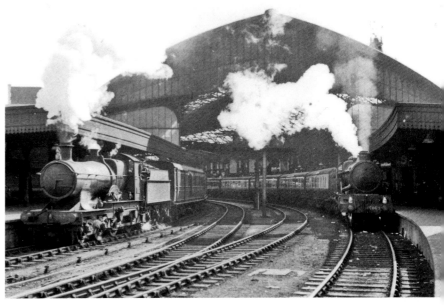

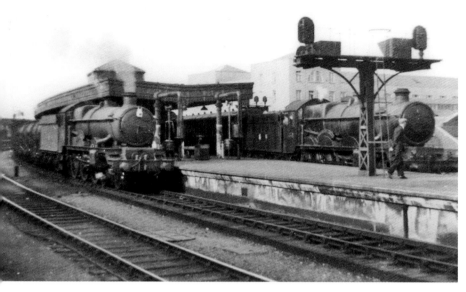

Bristol Temple Meads: Platform Scenes

In steam days, the platforms were numbered in logical sequence, although this may not have been entirely clear to ordinary travellers, as the longest platforms were treated as 'double' platforms and numbered accordingly. The island platforms on the eastern side of the station formed Platforms 1 and 2, while the neighbouring island comprised Platforms 3 and 4 – one of its two faces being regarded as a double-length platform. Down Platform 5 was flanked by up Platform 6, but Platforms 7 and 8, beneath the 1870s overall roof, were the two sides of a very long through platform. Moving westwards, Platforms 9 and 10 were the two parts of another very long island platform, while Platform 11 was a short bay on the up side. Finally, Platforms 12, 13, 14 and 15 were two double-sided platforms serving the original Brunel terminus on the north side of the station.

The upper picture shows the western end of the station in the late 1940s, with two unidentified 'Castle' class 4-6-0s, while the colour photograph shows a Virgin Cross Country service departing from Temple Meads behind class '47' locomotives Nos 47702 *County of Suffolk* and 47565 *Responsive* on 17 July 1999.

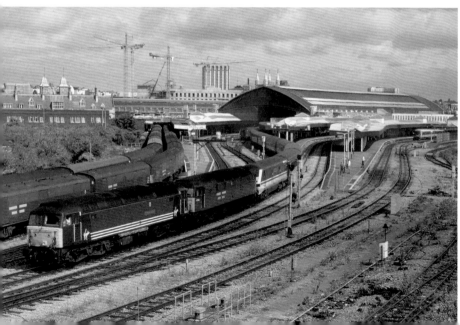